IMAGES
of America

ROWLEY

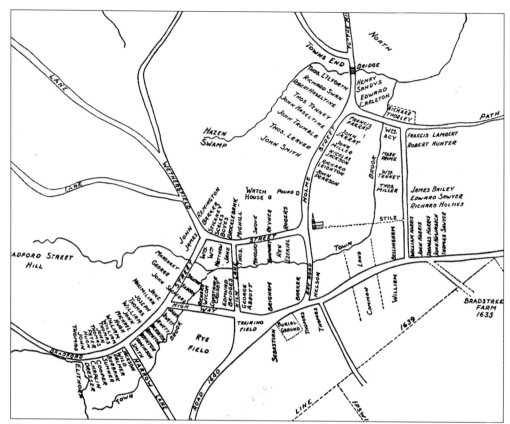

House Lots of 1639–1650. Seen here is a sketch of the house lots of Rowley's early settlers. (Courtesy Rowley Historical Society.)

THE ROWLEY TOWN SEAL.

On the cover: **AN EARLY HORSELESS CARRIAGE DISPLAYED BY LORENZO BRADSTREET, 1913.** The car is a two-person runabout with a convertible top. The early spoked wheels and carbide headlights were typical of the period. The unusual curved windshield deflector (usually a flat sheet of glass) is thought to be one of Bradstreet's inventions. Bradstreet was also the inventor of the Bradstreet Railroad Sleeping Car. (Courtesy Doris V. Fyrberg.)

IMAGES
of America

ROWLEY

Edward J. Des Jardins, G. Robert Merry,
and Doris V. Fyrberg
for the Rowley Historical Society

ARCADIA

First printed in 2002.

Published by Arcadia Publishing,
an imprint of Tempus Publishing, Inc.
2A Cumberland Street
Charleston, SC 29401

Printed in Great Britain.

Library of Congress Catalog Card Number: 2002108810

For all general information contact Arcadia Publishing at:
Telephone 843-853-2070
Fax 843-853-0044
E-Mail sales@arcadiapublishing.com

For customer service and orders:
Toll-Free 1-888-313-2665

Visit us on the internet at http://www.arcadiapublishing.com

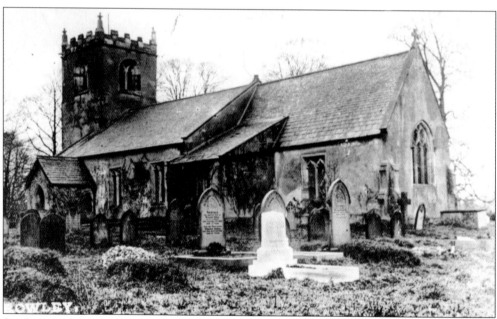

ST. PETER'S CHURCH, ROWLEY, YORKSHIRE, ENGLAND, C. 1930 POSTCARD. This church was built in the 13th century. In 1619, Rev. Ezekiel Rogers was appointed assistant pastor and remained there for 17 years. Harassed by the Church of England, 21 Puritan families left Rowley, England, in the ship *John of London* with Reverend Rogers and settled in America in 1639. Rowley, Massachusetts, is the only town in New England where Yorkshire families predominate. These early settlers, as cloth makers, established the first fulling mill in America on the Mill River in 1642, which marked the beginning of the textile industry in the colonies. (Courtesy Elizabeth Hicken.)

CONTENTS

ACKNOWLEDGMENTS

This book would not have been possible without the effort of numerous people and the several hundred historic images that were gathered. The huge collection of photographs that were available made the selection process by the authors very difficult. The Rowley turn-of-the-century photographic collections of Charles Houghton and A.O. Rogers brought our early history to light. We wish to thank the two other authors, Doris Fyrberg and Robert Merry, for their numerous photographs and meticulous historical research of many of the photographic images and their help in identifying many of those individuals pictured.

The Rowley Historical Society is indebted to the following individuals and organizations who have shared their photographic images as well as their knowledge of Rowley history: the historical society board of directors for financial support and encouragement; Grant from the Rowley Cultural Council; Elizabeth Hazen for typing and correcting several drafts of this text; Susan Hazen for proofreading; Scott Nason for supplying early glass negatives from the A.O. Rogers Collection; Elizabeth Hicken; Nathaniel N. Dummer; Steve Comley of Seaview Retreat Inc.; the Curtis F. Haley Collection, courtesy of Eva L. Haley; the Marian G. Todd Collection, courtesy of Frank and Shirley Todd; Edward Des Jardins; the Rowley Historical Society; the Rowley Free Public Library; Helen Foster; Jean Garnett; John Grover; Hazen Boyd; Louise Mehaffey; and Scott Leavitt.

Historical information was compiled from the following sources: *History of Rowley* and *The Tidal Marshes of Rowley and Vicinity*, by Amos Everett Jewett; *History of Rowley*, by Thomas Gage; *Land and Houses of Rowley*, by Nathaniel Dummer; *A Working Mill—America's Oldest Working Mill Site*, by Robert B. Chamberlain; the 1976 *Town Report of Rowley*; "America's Oldest Mill," by Paul Parker from *Yankee* magazine's June 1962 issue; the *Blake Hughes Sketchbook* article on Prime's Store; the *Massachusetts Historical Commission Survey*, 1976 and 1997; the 1905 *National* magazine article by George E. King; *Shoe and Leather Bulletin 1950—Foster's Shoe 100th Anniversary 1850–1950*; *Rowley, Massachusetts: A Historic Perspective*, by Marian Chase; and the *Tercentenary Publication 1639–1939*, by the Town of Rowley.

INTRODUCTION

Rowley, Massachusetts—earlier called "Mr. Ezechi Rogers Plantation"—has the distinction of being the only settlement in New England to have been settled entirely by families from Yorkshire, England. The Yorkshire men were clothiers and makers of cloth. In the fall of 1638, toward the close of the great Puritan migration, Rev. Ezekiel Rogers and his flock of about 20 families sailed from Hull on the Humber aboard the ship *John of London*. Rogers had recently been suspended from his ministry at St. Peters, Rowley, Yorkshire, for his puritanical ways and for refusing to read from a sports book on the Lord's day. The first printing press in America, the Daye Press, was also aboard the ship. Its first item printed after arrival was *The Freeman's Oath*, and its most valuable book printed in America was *The Bay Psalm Book 1640*.

Upon arriving, the land between Ipswich and Newbury was chosen for Rogers Plantation. Many additional families and friends soon joined the original 20 families to make a total of 60 first-settler families. At the time of Rowley's incorporation, "4–7 [September] 1639," Rowley was the fifth town to be settled in Essex County, the 16th in the Massachusetts Bay Colony, and the 26th in the nation. After the addition of the middle fifth of Plum Island in 1649, it was bounded northerly by Newbury, easterly by the ocean, southerly by Ipswich and Salem, and westerly by Andover and the Merrimac River. The original area known as Rowley also included the following towns, which were set off from the original grant: Bradford and part of Haverhill, 1675; Boxford, 1685; part of Middleton that once belonged to Boxford, 1728; Georgetown, 1838; and Groveland (formerly known as East Bradford), 1850. In 1785, after many petitions to Ipswich and the General Court, several hundred acres—including the King Grant farms of Humphrey Bradstreet and John Cross—were annexed to Rowley.

The settlers labored together to set out the first roads and house lots along the Town Brook (later called Tan House Brook), their only source of water. They also set apart land for training the militia called the Training Place, now the town common. There were many hardships, including Indian hostilities and the witchcraft hysteria. Garrisons were built to warn of Indian attack and, in 1692, two Rowley women were accused of being witches. At the Salem witchcraft trials, Margaret Scott was put to death by hanging, along with several others, on September 22, 1692. Mary Post was accused but later reprieved. They were victims of the delusion and the superstition of the times.

However, the Yorkshire people were very industrious in many ways. They built gristmills, sawmills, and tanneries along the Mill River and were responsible for starting the textile industry in the New World with the building of the first colonial fulling mill in 1643. Later, this whole mill complex passed from the Pearson family (builders) to the Dummers. The Glen Mills Cereal Company became well known. Disaster struck, however, when fire destroyed the gristmill operation in 1916. The boardinghouse and carriage sheds remain today. The salt-box building and the overshot water wheel are part of the restoration work done by Paul Parker in the 1940s. The water was used for power to turn the wheel for the polishing of gems and stones. Today, the wheel is silent, but it is a popular photographer's subject. The 1642–1643 Old Stone Arch Bridge, built by Richard Holmes, as well as the Mill River Dam across the street, are mute reminders of an era gone by. The Glen Mills Historic District and the Rowley Center Historic District are protected and preserved by a town bylaw that was adopted in 1987.

Hopefully, this publication will be helpful for those studying local history or genealogy. Possibly, others will visualize what it would have been like to go to a one-room district schoolhouse, walking both ways and always carrying a bag lunch. Maybe, others will imagine what it would have been like to go marsh haying, to learn how to make a perfect strawberry-shaped haystack on a staddle on the marsh, or to go riding on an open electric streetcar on the way to Hampton Beach.

FOREWORD

The Rowley Historical Society will be forever grateful to the three authors, society members Doris V. Fyrberg, G. Robert Merry, and Edward J. Des Jardins, who took on the enormous task of compiling and sorting through hundreds of photographs and researching to accurately present an outstanding pictorial history of early Rowley. Many of these photographs, taken at the turn of the century from early glass negatives, have never been seen by the community, and we are happy to share them with you.

I am greatly indebted to the two other authors for the many hours they spent with me making this comprehensive book possible. With this publication, the Rowley Historical Society has accomplished a number of goals, which include cataloguing and preserving an excellent Rowley photographic collection from early glass negatives and sharing these historic images with residents and visitors to our community. Proceeds from the sale of this book will also allow the society to further the work of historic preservation at the 1677 Platts-Bradstreet House and 1775 Barn-Museum. We hope you enjoy this book as much as we have enjoyed bringing Rowley's unique history to you.

—Edward J Des Jardins, President, Rowley Historical Society

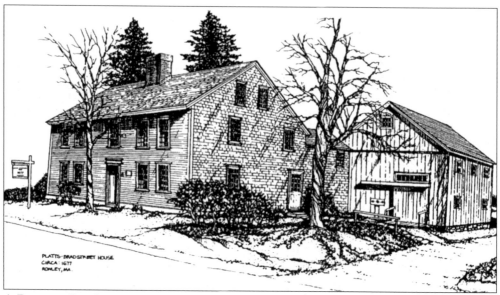

A PEN-AND-INK SKETCH BY HISTORICAL SOCIETY PRESIDENT EDWARD J. DES JARDINS. The Rowley Historical Society's 1677 Platts-Bradstreet House and 1775 Barn-Museum are located on Main Street. The early barn was recently dismantled and reconstructed over a four-year period on the historical society site, primarily by society volunteers. (Courtesy Edward J. Des Jardins.)

One

VILLAGE CENTER AND OUR TOWN

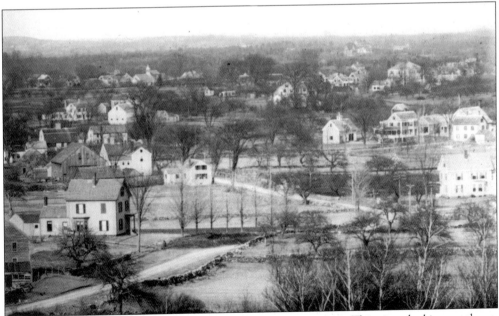

A BIRD'S-EYE VIEW OF ROWLEY FROM PROSPECT HILL, C. 1900. This view, looking northeast, shows Haverhill Street in the foreground. (Charles Houghton Collection; courtesy Doris V. Fyrberg.)

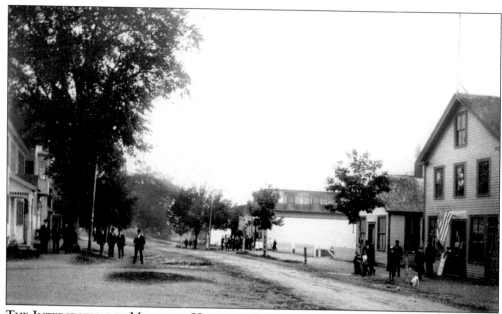

THE INTERSECTION OF MAIN AND HAMMOND STREETS, C. 1897. This photograph, taken on Decoration Day, May 31, 1897, depicts the Rowley Village Center looking south. The store in the center was moved around the corner to Hammond Street in 1933 to become the Rowley Fire Station. (A.O. Rogers Collection; courtesy Scott Nason.)

THE INTERSECTION OF MAIN AND CENTRAL STREETS, C. 1905. Note the recently built (1904) Center School in the background to the far right. (Curtis F. Haley Collection; courtesy Eva L. Haley.)

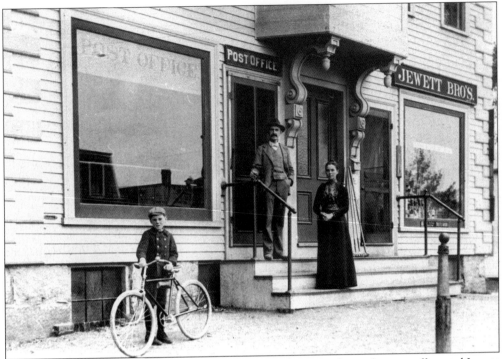

THE VILLAGE CENTER ON MAIN STREET, C. 1900. This view shows the post office and Jewett Brothers Grocery Store. Standing outside of the establishment, from left to right, are young J. Robert Marshall, postmaster John A. Marshall, and Alice Marshall. (Curtis F. Haley Collection; courtesy Eva L. Haley.)

HOUSE-MOVING DAY IN ROWLEY, C. 1900. It was not unusual to see buildings moved from street to street at the turn of the century. This photograph shows H.N. Hayward's Grocery Store—present site of the Rowley Pharmacy—being moved onto Main Street. Note the Congregational church parsonage and church spire in the background center of the picture. (A.O. Rogers Collection; courtesy Scott Nason.)

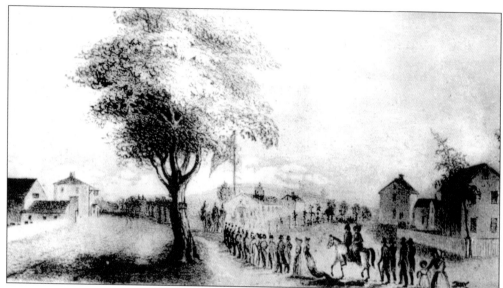

THE BICENTENNIAL DINNER ON THE TOWN COMMON, 1839 PAINTING. This early painting depicts the town's 200th anniversary, held on September 5, 1839. For the celebration, "A substantial pavilion, 160 ft x 25 ft in width, was erected on the Common where approximately 400 gentlemen and ladies partook of a dinner prepared by Edward Smith and John B. Savory, Esquires." (Printed by Sharp Michelin & Company; courtesy Rowley Historical Society.)

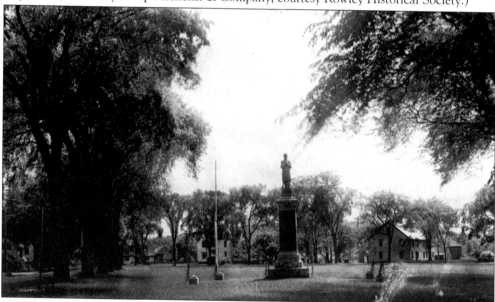

THE TOWN COMMON AND CIVIL WAR MONUMENT, C. 1930 POSTCARD. The Civil War monument on the town common was dedicated on Dec. 12, 1914. The common, or the Training Place, as it was called earlier, is triangular in shape and is bordered by shade trees on all sides. In 1839, 100 young elm trees were planted in town, some around the perimeter of the common for decorative purposes. The 1640 Bay Road, now called Main Street, borders on the east side and Summer and Independent Streets on the other sides. The Training Place has remained just as it was originally laid-out by the first settlers. It has been the scene of many celebrations over more than 350 years. (Courtesy G. Robert Merry.)

THE EBEN BOYNTON HOUSE ON SUMMER STREET FACING THE ROWLEY COMMON, C. 1898. The house and barn were built prior to 1769. In 1770, blacksmith Richard Lowell lived here and, in 1801, Benjamin Bishop sold the land, buildings, shed, shop, sign, and signpost to Eben Boynton. The house was moved here prior to 1769 with the intention of placing it back from the street, but it got stuck in the mud and was left just where it landed. William and Charles Boynton were cabinetmakers, and much of their handicraft can be found in Rowley homes. In 1918, Frank L. Burke made the barn into a house. (A.O. Rogers Collection; courtesy Scott Nason.)

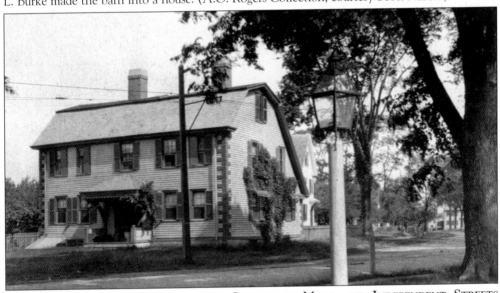

THE MIGHILL-PERLEY HOUSE ON THE CORNER OF MAIN AND INDEPENDENT STREETS (SOUTH END OF THE ROWLEY COMMON), C. 1900 POSTCARD. Built by Capt. Nathaniel Mighill in 1730, this interesting house has oak rafters hewn of logs with a natural crook, which extend from the eaves to the ridge pole. In front of this house, Capt. Nathaniel Mighill Perley, grandson of the builder, built the ship *Country's Wonder*, a vessel of 100 tons burden, which was hauled to the Warehouse Landing on May 2, 1814, by more than 150 yoke of oxen. (Courtesy Rowley Historical Society.)

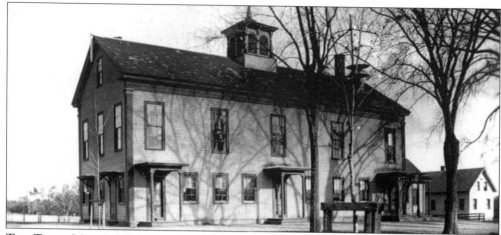

THE THIRD MEETING HOUSE, C. 1900 POSTCARD. Built in 1847, the building was originally Rowley's fourth schoolhouse until 1904, when the Center School was built. The upstairs has also served as the town hall from 1847 until 1904—the year the town hall was built on Main Street. When the Center School was completed. This old building was cut in half and moved down over the hill to its current location as the present Grange Hall. The other half of the old schoolhouse was also moved and is located on the adjacent lot, now used as a dwelling. (Courtesy G. Robert Merry.)

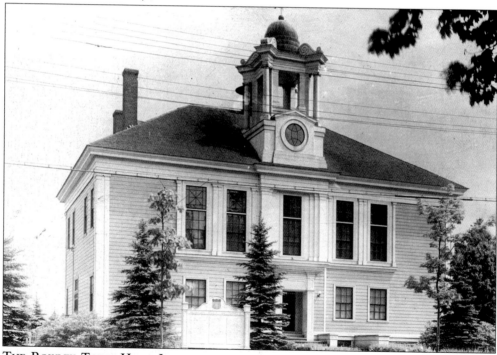

THE ROWLEY TOWN HALL, LOCATED BEYOND THE BURIAL GROUNDS ON MAIN STREET, C. 1910 POSTCARD. The town hall was built in 1904 with a gift from benefactor David E. Smith. The cupola dome is topped by an Indian archer weathervane. The upstairs hall contains a rare collection of birds donated to the town by Charles Houghton, who, as photographer at the turn of the century, was also responsible for many of the photographs in this book.(Courtesy G. Robert Merry.)

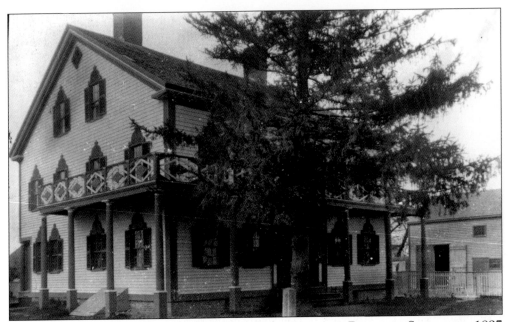

THE HENRY BOYNTON HOUSE ON THE CORNER OF MAIN AND PLEASANT STREETS, C. 1897
PHOTOGRAPH. The house was originally built in 1749. A good portion of the building material
used during the construction was taken from the Third Meeting House. Note the Victorian
elements, like the second floor balcony and decorative treatment of the windows, added in the
early 1890s. (A.O. Rogers Collection; courtesy Scott Nason.)

THE TOWN HALL'S INDIAN ARCHER
WEATHERVANE ON THE CUPOLA DOME,
MAIN STREET, C. 1975 PHOTOGRAPH.
This late-19th-century copper
weathervane was previously used on the
old town hall and school on Central
Street. The Massasoit Indian archer is
the chosen emblem of the Massachusetts
Bay Colony. It resembles the handiwork
of Deacon Shem Drowne of Boston, who
made a similar weathervane used in the
1600s to adorn the old Province House
mansion in Boston, the ancient abode of
the royal governors. A duplicate of this
weathervane is presently on display at
the Smithsonian Institute in
Washington, D.C. (Photograph by
Hazen Boyd; courtesy G. Robert Merry.)

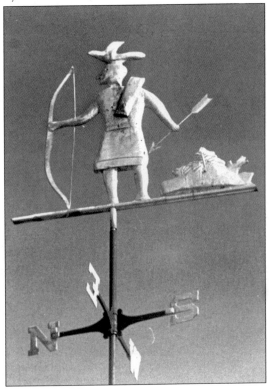

15

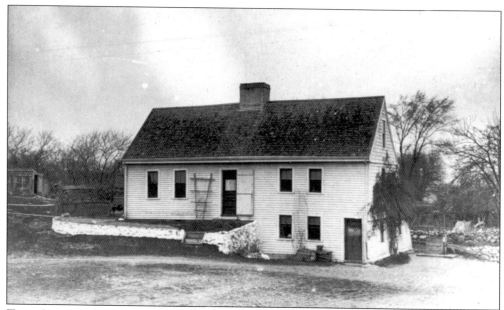

THE CHAPLIN-CLARK HOUSE AT 109 HAVERHILL STREET (ROUTE 133), C. 1900 POSTCARD. Built in 1671, the house is Rowley's oldest dwelling. It has a central chimney built on a stone foundation, as well as an unusual feature: a slight overhang on both the first and second stories on the east end, but none on the front. The building also has a lean-to (a very early addition) and is the only one in Rowley that has both an overhang and a lean-to. Richard Clark and one of his children died of smallpox in 1730; their unmarked graves lie west of the house by the stone wall. The house is listed on the National Register of Historic Places. (Courtesy G. Robert Merry.)

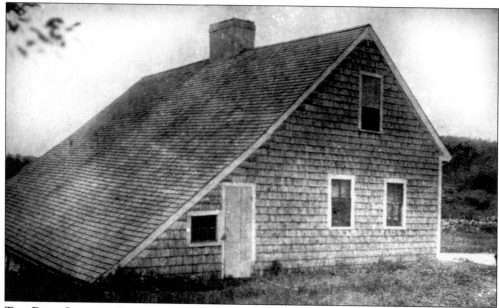

THE ROOF LEAN-TO DOWN TO GROUND LEVEL. This rear view of the Chaplin-Clark House shows the lean-to at ground level.

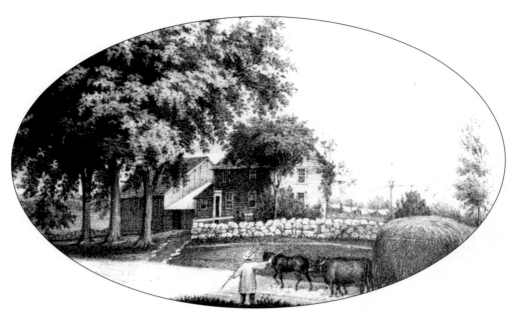

A PAINTING OF THE PARRAT JEWETT HOUSE AND BARN ON CROSS STREET BY SAMUEL GERRY, C. 1900 POSTCARD. The Parrat Jewett House is an early-18th century half house. The gentleman in the painting is Daniel Todd, along with his horse and team of oxen pulling the hay wagon. The building was taken down in 1875. The original painting is located at the Rowley Historical Society's Platts-Bradstreet House. (Courtesy Elizabeth Hicken.)

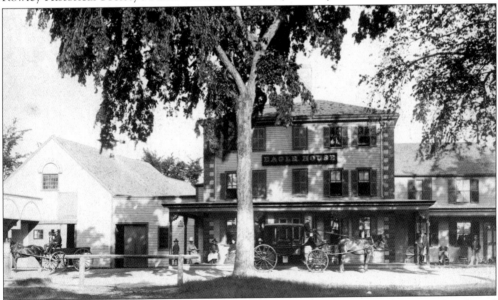

THE EAGLE HOUSE ON MAIN STREET, C. 1900 PHOTOGRAPH. Built by James Smith and opened in 1806, the Eagle House was well known in this region, holding elaborate conventions and parties and featuring the best speakers of the day. Rowley's first post office was located here. The Smiths operated the hotel until 1901. It burned down in 1919. In 1933, the land was purchased by Thornton Burgess, a noted naturalist, who leased the site to the American Oil Company, which became the Knowles Amoco Station. It is the present site of the Richdale store. (Courtesy Rowley Historical Society.)

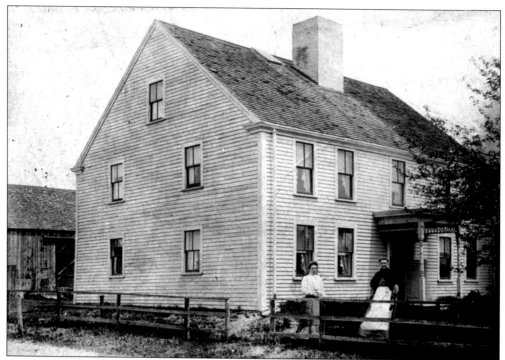

THE MARGARET STEPHENSON SCOTT HOUSE AND BARN ON CENTRAL STREET, C. 1900. Members of the Addison family are shown in the foreground. The house was built in 1676 by Benjamin Scott. Margaret Scott was Rowley's only victim of the Salem witchcraft trials and was put to death by hanging in Salem on September 22, 1692. (Courtesy G. Robert Merry.)

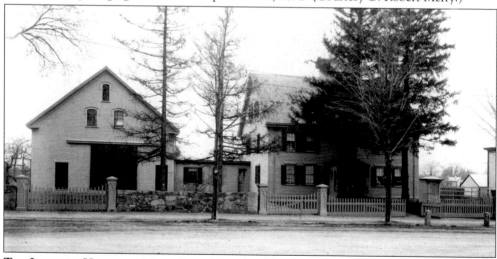

THE LAMBERT HOUSE ON MAIN STREET, OPPOSITE THE ROWLEY TOWN HALL, C. 1897. The house was built in 1699 by the Honorable Thomas Lambert and is listed on the National Register of Historic Places. The site is located on the original land grant of Thomas Barker in 1639. It was owned until 1954 by his great-great-great-great-granddaughter Mrs. Knight Dexter Cheney, then by Ruth and Adrian Lambert, and later by John T. Lambert of New York. It remained in the Lambert family for nearly 300 years. (Charles Houghton Collection; courtesy Doris V. Fyrberg.)

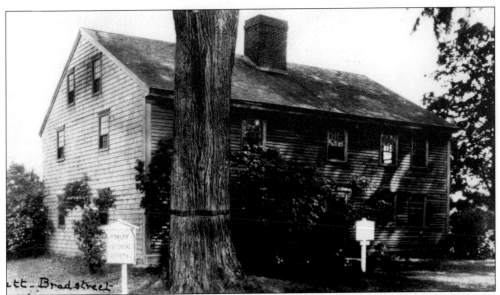

THE PLATTS-BRADSTREET HOUSE ON MAIN STREET, OPPOSITE PLEASANT STREET, C. 1900 POSTCARD. The house was built before 1677 by Samuel Platts and was owned by the Platts family until 1771, then by the Bradstreet family until 1906. It was originally a four-room house; the lean-to was added *c.* 1725, and the rear section was raised in 1771. In 1890, a two-story ell addition was added for caretakers' quarters. A *c.* 1775 post-and-beam barn from New Hampshire was dismantled and reassembled at the rear of the house in 1998 to replace a former barn on the site. The Platts-Bradstreet House is on the National Register of Historic Places and is owned by the Rowley Historical Society; it is one of six known 17th-century houses in Rowley. (Courtesy G. Robert Merry.)

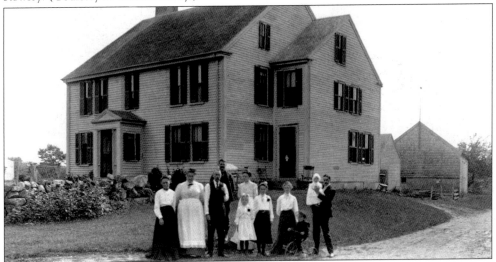

THE ABRAHAM JEWETT HOUSE ON MAIN STREET, C. 1890s. The entire Saunders family poses for the photographer. Note the youngster on his tricycle in the front row. Originally built *c.* 1660, the building has had many additions over the years. The main house faces Main Street, which was called the 1640 Bay Road. Abraham Jewett was listed as a tanner in early town records. The building is now the Village Pancake House Restaurant. (A.O. Rogers Collection; courtesy Scott Nason.)

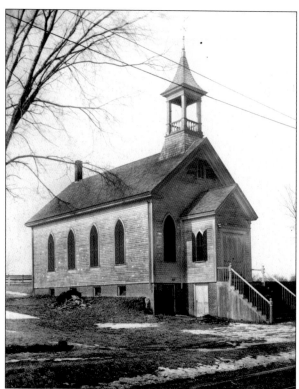

THE UNIVERSALIST CHURCH ON CENTRAL STREET, C. 1900. The church building was later converted to an apartment house in 1920 and burned down shortly after. (Marian G. Todd Collection; courtesy Frank and Shirley Todd.

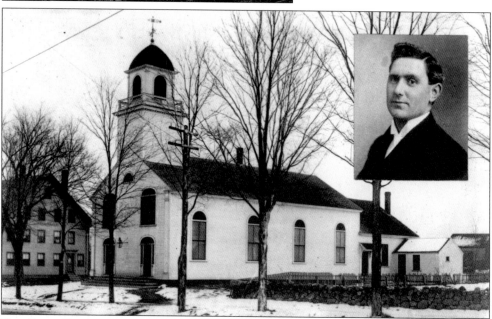

THE FIRST BAPTIST CHURCH OF ROWLEY ON MAIN STREET NEXT TO THE TOWN HALL, C. 1898. The building was erected in 1830 at the site of the original lot of Thomas Barker and was known as the Second Baptist Church of Rowley at that time. The church in the western part of Rowley (now Georgetown) was the First Baptist Church until 1838, when Georgetown was formed. (Charles Houghton Collection; courtesy Rowley Historical Society.)

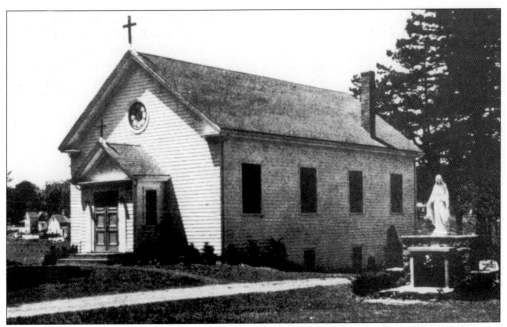

THE ORIGINAL ST. MARY'S CATHOLIC CHURCH ON MAIN STREET, C. 1940s. The building was extensively renovated from an existing large barn and converted into a charming little church, which was dedicated on August 26, 1923. The building was badly damaged by fire in 1959, and the new church was built and dedicated in October 1960. (Courtesy G. Robert Merry.)

THE FOURTH MEETING HOUSE OF THE FIRST CONGREGATIONAL CHURCH ON THE CORNER OF MAIN AND HAMMOND STREETS, C. 1940s. The present church was built in 1842 by Mark Jewett. The original church and meeting house, erected at the intersection of Central and Wethersfield Streets, was dedicated on December 3, 1639, and was used not only for worship, but also for the transaction of town business and activities. In 1695, the town voted to build a new meeting house, the second. The third meeting house was built in 1749 (54 years later) as a replacement. In 1842, parishioners were divided about changing the location to the corner of Main and Hammond Streets. The vote to change the location was won by just one vote (24 to 23). (Courtesy G. Robert Merry.)

21

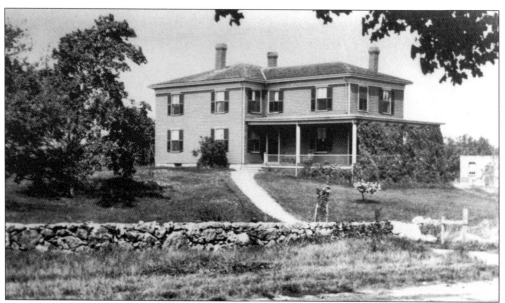

THE GEORGE BLODGETT HOUSE ON CENTRAL STREET, C. 1930 PHOTOGRAPH. The house was built in 1871. George Blodgett was a local lawyer, genealogist, and compiler of several articles on Rowley history. Blodgett was also the author of the book *Blodgett and Jewett's Early Settlers of Rowley*, with Amos E. Jewett completing the document upon the death of Blodgett. His home is presently the site of the Plantation, the Rowley Housing Authority Complex. (Curtis F. Haley Collection; courtesy Eva L. Haley.)

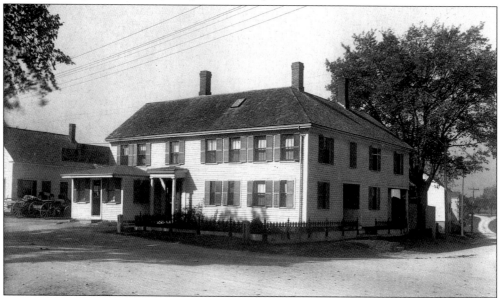

THE HALE-BOYNTON RESIDENCE ON THE CORNER OF SUMMER AND INDEPENDENT STREETS, C. 1930S PHOTOGRAPH. Built before 1780, this two-story house is L-shaped and contoured to the corner lot of first settler Edmund Bridges, who was a blacksmith. It was also the home of Dr. William Hale, physician and teacher, during the Revolutionary War years. Dr. Hale was responsible for caring for the smallpox victims who stayed at the pest house, which was built in the Metcalf Rock Pasture off of Haverhill Street. (Courtesy Rowley Historical Society.)

Two
PEDDLERS AND
BUSINESSES

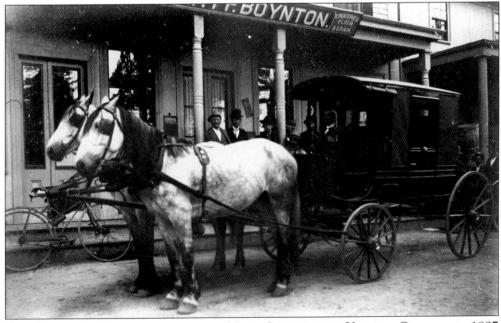

THE HENRY P. BOYNTON BLOCK ON MAIN STREET, THE VILLAGE CENTER, C. 1897 PHOTOGRAPH. The building, constructed prior to 1795, had multiple occupants—from a grocery store to a heel factory to a livery stable. The team of horses and passenger wagon in front of the store is driven by teamster George Evans. The Village Center was the hub of activity at the turn of the century. The site is now the location of the town hall. (A.O. Rogers Collection; courtesy Scott Nason.)

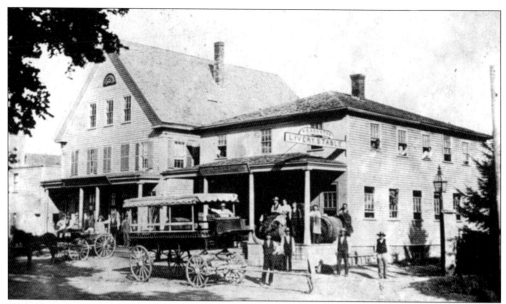

THE BOYNTON BLOCK'S ENTIRE COMPLEX ON MAIN STREET, LOOKING SOUTH, C. 1900 PHOTOGRAPH. Note the horse-drawn barge parked in front of store and the dry goods stored outside on the front porch. Hacks were parked outside to take passengers to the train depot. The structure was built in 1857 and was later destroyed in a fire on April 2, 1902. (Courtesy Doris V. Fyrberg.)

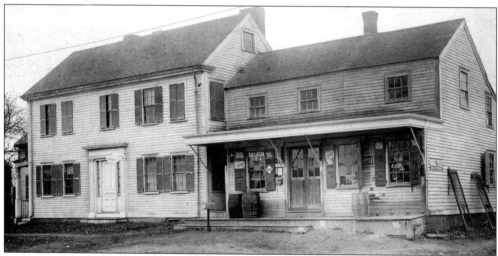

PRIME'S STORE ON CENTRAL STREET, C. 1910 POSTCARD. Mark Prime built this store in 1707 to supply the pioneer inhabitants of Rowley, Ipswich, Newbury, and the surrounding scattered settlements with the necessities that could not be produced on their own farms. Mark Prime's account book lists numerous items used by the early pioneers. No entries appear as frequently as those for ardent spirits, especially New England Rum, or "white face," as it was affectionately known. The owner and his wife were frequently awakened at night to supply rum to people who were headed out into the marshes. Tonic to deal with the mosquitoes, no doubt! The store served Rowley and its vicinity for 236 years—probably the oldest store in continuous operation in New England and certainly the longest run by one family. It is now part of a private residence. (Courtesy G. Robert Merry.)

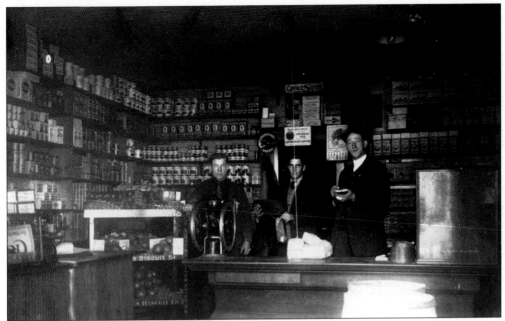

THE INTERIOR OF JEWETT'S GROCERY STORE ON MAIN STREET IN THE VILLAGE CENTER, C. 1910 PHOTOGRAPH. Chester Savage is located to the right in the photograph. Note the ball of string mounted to the ceiling in order to tie-up customers' packages. Other items of interest include the coffee grinder on the counter and the grains stored in the barrels with measuring containers and fresh produce. (Courtesy Doris V. Fyrberg.)

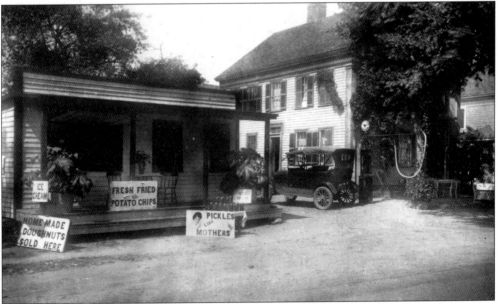

MILLETT'S ROADSIDE STAND ON MAIN STREET, C. 1920s PHOTOGRAPH. This welcome refreshment stand sold ice cream, homemade donuts, fresh fried potato chips, sandwiches, and hot tea and coffee and featured "pickles like mother's." Note the antique car and gas pump to the right of the stand, as well as the separate picnic area. (Charles Houghton Collection; courtesy Doris V. Fyrberg.)

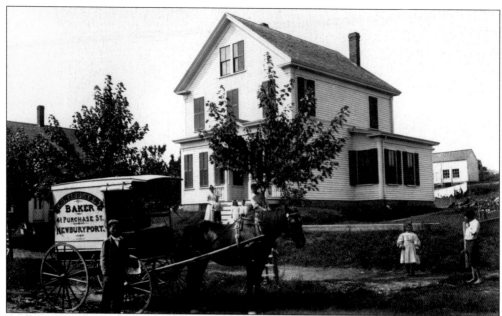

A NEWBURYPORT PEDDLER PARKED IN FRONT OF THE JOHN WORTHLEY HOME ON RAILROAD AVENUE, 1897 PHOTOGRAPH. Note the family members gathered outside the house and the barefoot boy with knickers to the right in the photograph. (A.O. Rogers Collection; courtesy Rowley Historical Society.)

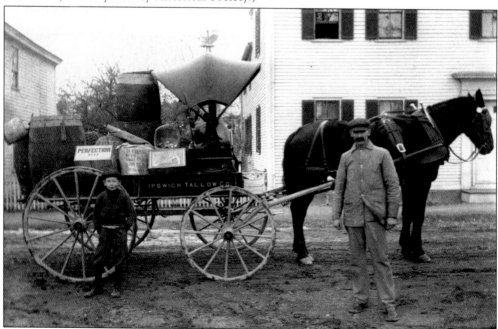

A PEDDLER FROM THE IPSWICH TALLOW COMPANY, C. 1900 PHOTOGRAPH. The peddler sells soap products to housewives and collects fat renderings in the barrels as he travels along Summer Street, with Charles Houghton's property in the background. Note the unusual shade canopy over the driver's seat. (Charles Houghton Collection; courtesy Rowley Historical Society.)

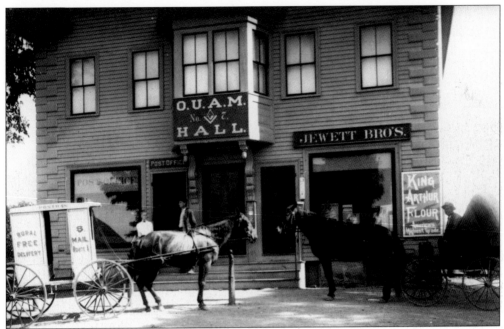

THE JEWETT BROTHERS STORE AND POST OFFICE ON MAIN STREET, C. 1905 PHOTOGRAPH. The U.S. Mail rural delivery wagon is shown to the left outside of the post office. The Order of United American Mechanics (OUAM) Masonic Hall is located on the second floor of the building. Note the King Arthur Flour sign outside the grocery store to the right. (Marian G. Todd Collection; courtesy Frank and Shirley Todd.)

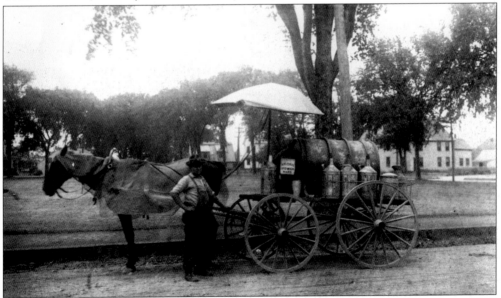

PEDDLER A.H. GRAY OF IPSWICH ON SUMMER STREET NEAR THE TOWN COMMON, C. 1905 PHOTOGRAPH. The peddler, with his tank wagon and umbrella, dispenses fuel and lamp oil in the community. Electric lighting did not come to town until 1910. Note the unusual netting draped on the horse to keep the flies away. (Charles Houghton Collection; courtesy Rowley Historical Society.)

27

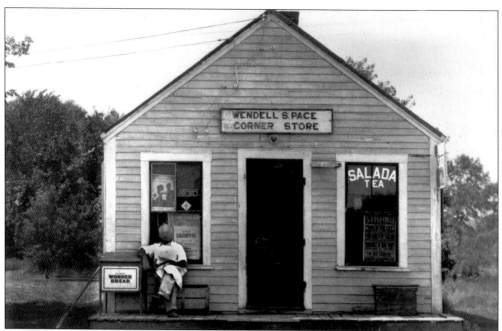

THE WENDELL S. PACE CORNER STORE AT MAIN STREET AND RAILROAD AVENUE, C. 1940 PHOTOGRAPH. Pace is seated near the entrance at the front of his store. Note the posters of local attractions displayed in his windows. (Courtesy Elizabeth Hicken.)

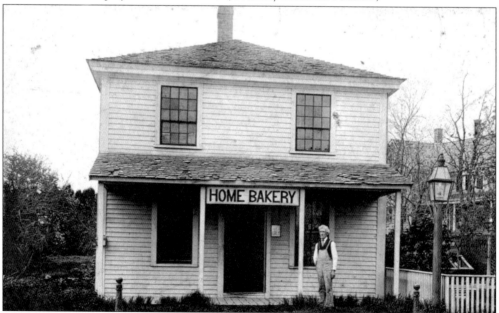

CHARLES A. HOUGHTON OUTSIDE HIS BAKERY ON SUMMER STREET, OPPOSITE THE TOWN COMMON, C. 1900 PHOTOGRAPH. Houghton's other businesses included a printing office and a photographic studio; he is credited with a number of turn-of-the-century photographs in this book. Charles Houghton also donated an extensive and rare bird collection to the town, which is displayed on the second floor of the town hall. Note the oil street lamp and hitching posts to the right in the photograph. (Charles Houghton Collection; courtesy Rowley Historical Society.)

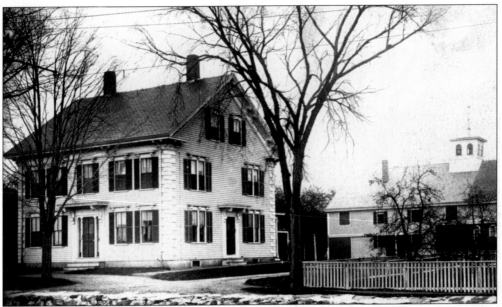

The Titcomb House and Barn on Central Street, c. 1910 Postcard. Mr. Titcomb operated a grocery store. The barn burned down in 1928 just after the Rowley Fire Department was formed. Hose lines were laid from the town brook but were two lengths too short to fight the fire. By the time additional hose lines had arrived from Ipswich, the barn was destroyed. The house was recently moved to Scottfield Road. (Courtesy G. Robert Merry.)

1830 **Titcomb's** Ipswich 82 1939
Rowley 76
Topsfield 230

Celery	Middle	Corned Beef Cut from best corn fed steers	12½
Peas	Rib		
Lettuce	SWIFT'S PREMIUM LAMB		
Carrots			
Cabbage	Lamb Fores Boned & Rolled If you wish	12½	
Onions			
Tomatoes	Leg & Loin	24	
Parsley			
String Beans			
Sweet Peppers			
Mushrooms			
Turnips	Armour's HAMS Whole or Shank Half	25	
Native	Native BROILERS 2½lb. av.	28	
Blueberries	Dressed		
Cantalopes			
Honeydew	Rib Roast From best prime beef	25	
Melons			
Egg Plant			
Green Corn			
Peaches	Boneless Chuck Oven or Pot Roast	27	
Spinach All at			
Market Prices			

Cold Cuts – Minced Ham – Baked Ham
Bologna – Livewurst – Combination Loaf
Chicken Loaf – Dutch Loaf – Spiced Ham
Cooked Corned Beef – Beef Loaf

PORK CHOPS 25

Oranges-Lg. Florida 39–Cal. med. 25–sm. 2 dz. 29

A Titcomb Advertising Card, c. 1939. The Rowley store was one of the three located in the area. Mr. Titcomb established the company in 1830. Note the prices of the products he sold when compared to today's prices. (Courtesy G. Robert Merry.)

29

MRS. JERRY TODD'S FIRST STORE, C. 1900 POSTCARD. The store was located on Main Street between the Baptist church and the church parsonage. (Courtesy Elizabeth Hicken.)

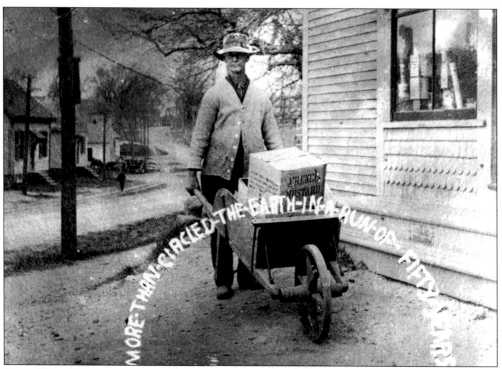

JERRY TODD'S GROCERY STORE ON THE CORNER OF MAIN AND CENTRAL STREETS (BAILEY'S CORNER), C. 1910 POSTCARD. Here, Jerry Todd comes with a fresh supply of French's mustard in his wheel barrel. His building on the right was later moved to Central Street and became part of Milford Daniel's Hardware Store. (Courtesy G. Robert Merry.)

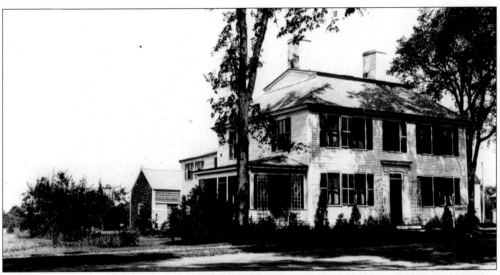

THE COLONIAL REST INN AT THE CORNER OF MAIN AND PLEASANT STREETS, C. 1900 POSTCARD. The inn, formerly called the Lt. John Harris House, is a Georgian-style dwelling with a hip-mansard-type roof and central entrance. It is important, as it is the only house of this style in Rowley. This dwelling was one of the many inns located in the Rowley area in the 1920s and 1930s. Lt. John Harris, who built the house in July 1805 for his bride, died a few months later on October 7, 1805, at 33 years of age. He was a lieutenant in the local military band of soldiers that helped protect the town. Most recently, the renovated barn has become the home of Salt Marsh Antiques. (Courtesy Elizabeth Hicken.)

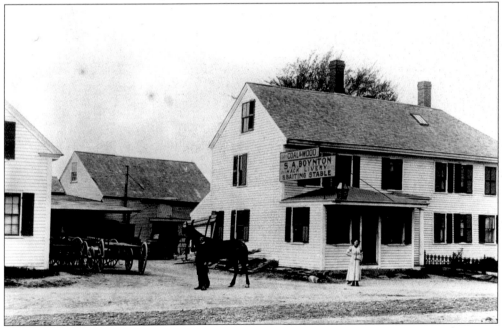

S.A. BOYNTON'S LIVERY STABLE ON THE CORNER OF SUMMER AND INDEPENDENT STREETS, C. 1910 POSTCARD. Boynton's Livery Stable supplied coal and wood, hack passenger service, livery freight service, and baiting stable. The site later became "Hosey" Hammatt's Garage. (Courtesy Elizabeth Hicken.)

31

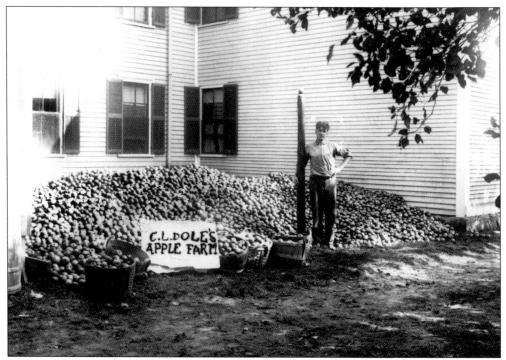

C.L. DOLE'S APPLE FARM ON SUMMER STREET, C. 1920S PHOTOGRAPH. These orchards produced an excellent assortment of apples. The Dole complex was also known for its large dairy farm. (Courtesy Doris V. Fyrberg.)

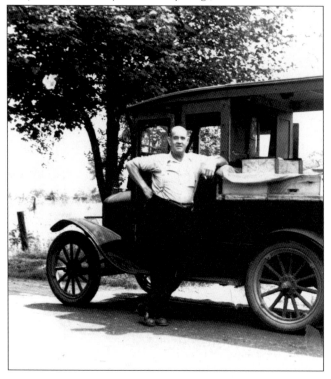

HAZEN JEWETT WITH HIS PRODUCE TRUCK, C. 1920S PHOTOGRAPH. Hazen Jewett was also one of Rowley's early police chiefs and an overseer of the cannon Old Nancy in the 1930s. (Courtesy Elizabeth Hicken.)

A DODGE'S BIG DRINK AND CIDER MILL ADVERTISEMENT, 1966. Located on the corner of Wethersfield Street at Route 1, this was a great gathering place to spend time with friends for an ice cream or a Dodge's Big Drink in the 1950s and 1960s. (Courtesy G. Robert Merry.)

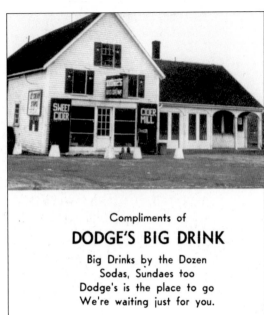

Compliments of

DODGE'S BIG DRINK

Big Drinks by the Dozen
Sodas, Sundaes too
Dodge's is the place to go
We're waiting just for you.

Pa Tater says:

Congratulations, Class of '66

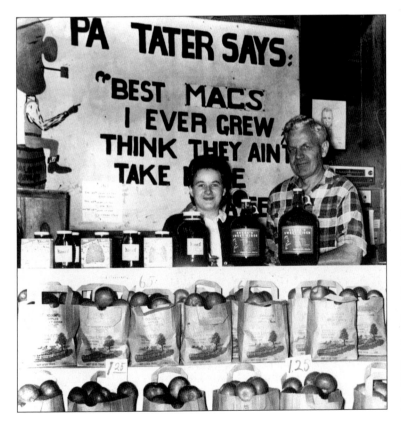

THE INTERIOR OF THE CIDER MILL WITH APPLES, CIDER, AND OTHER PRODUCTS, 1963 PHOTOGRAPH. Paul Dodge is shown on the right with an employee to his left. The business began in 1935 and closed in the late 1960s. Note the fresh-picked Gravenstine apples for 65 cents a bag. (Courtesy G. Robert Merry.)

33

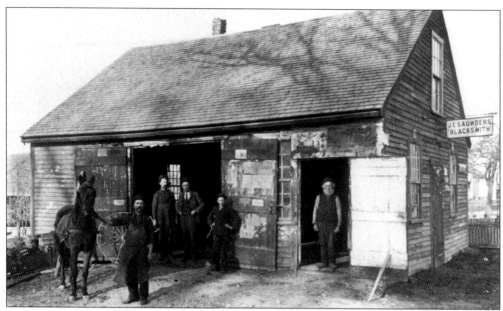

THE JAMES E. SAUNDERS BLACKSMITH SHOP ON MAIN STREET, 1898 PHOTOGRAPH. In the foreground, James Saunders, in a leather apron, holds onto the horse. The building was later moved to Central Street, becoming the Alex Smith Blacksmith Shop and then Milford Daniel's Hardware Store. (A.O. Rogers Collection; courtesy Scott Nason.)

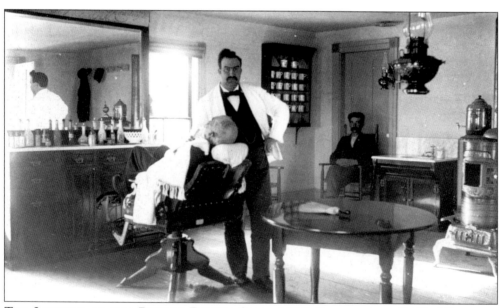

THE INTERIOR OF THE ROWLEY BARBER SHOP, 1897 PHOTOGRAPH. H.W. Allen gives customer Mr. Cook a shave with a straight razor while Mr. Cook's son waits for his turn. Note the hot water container on top of the stove and the customers' private shaving mugs stored on the shelves at the rear. (A.O. Rogers Collection; courtesy Scott Nason.)

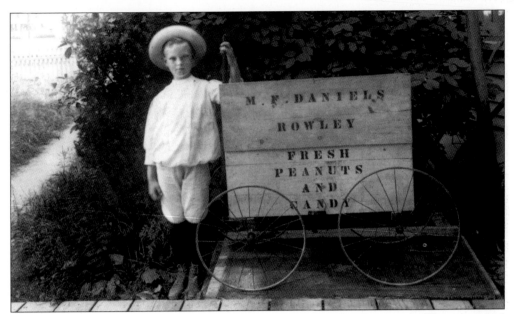

THE YOUNG ENTREPRENEUR MILFORD F. DANIELS WITH HIS PEDDLER'S WAGON, 1910 PHOTOGRAPH. The youngster sells fresh peanuts and candy next to Houghton's Bakery on Summer Street. (Courtesy Doris V. Fyrberg.)

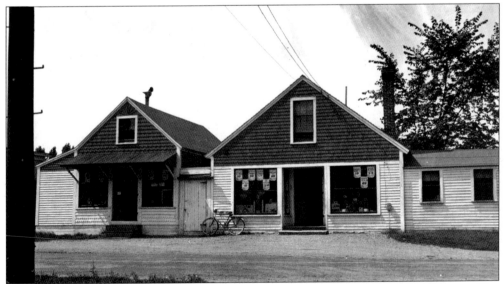

MILFORD DANIELS'S HARDWARE STORE ON CENTRAL STREET, C. 1930S PHOTOGRAPH. The right portion of the building was originally the James E. Saunders Blacksmith Shop, which was moved from Main Street c. 1900. The left section of the building was a portion of Jerry Todd's Grocery Store, moved from Bailey's Corner in 1921. (Charles Houghton Collection; courtesy Rowley Historical Society.)

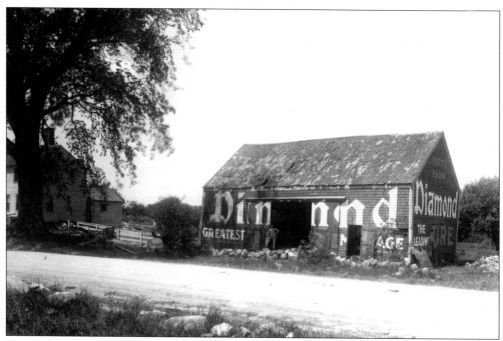

A DIAMOND TIRE ADVERTISEMENT PAINTED ON THE BARN NEXT TO CAPT. EDWARD SAUNDERS'S HOUSE ON MAIN STREET, C. 1905 PHOTOGRAPH. These hand-painted advertisements were commonplace at the turn of the century. The local advertising agent would offer to paint three sides of a barn any color the farmer wanted for free, if the farmer would let the agent paint his product's name on the side that faced the road. (Charles Houghton Collection; courtesy Rowley Historical Society.)

McCARTHY'S GARAGE AND SERVICE STATION AT MAIN STREET AND RAILROAD AVENUE, C. 1930s POSTCARD. This was the site of the F.L. Burke Wood Heel Factory and is now the site of Rowley Auto Body. (Courtesy Elizabeth Hicken.)

Three

INDUSTRIES—FROM
SHOES TO BOATS

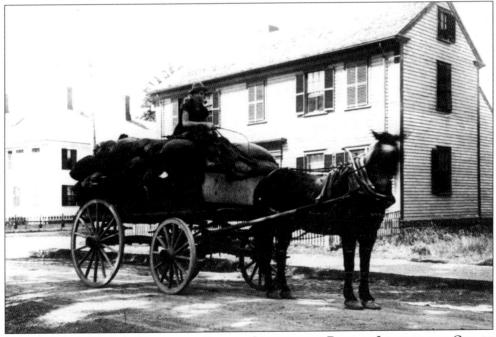

THE BOYNTON EXPRESS WAGON ON SUMMER STREET WITH BAGS OF LEATHER FOR ONE OF THE NEARBY SHOE MANUFACTURERS, 1910 PHOTOGRAPH. The Dr. Abbott House is in the background beyond the wagon. The shoe industry played a major role in Rowley's history at the turn of the century, employing hundreds of workers. William C. Foster & Sons and Edward Kimball manufactured boots and shoes, while four factories in town manufactured heels: S.A. Boynton, Milton Ellsworth, Mooney & Richardson, and F.L. Burke & Son, with a factory in Rowley and in Ipswich. (Courtesy G. Robert Merry.)

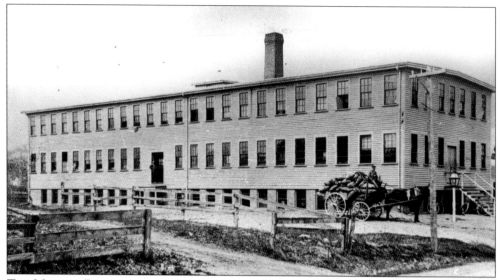

THE MOONEY RICHARDSON SHOE FACTORY ON HAMMOND STREET, C. 1905 PHOTOGRAPH. Worker William Hammond stands at the loading dock of this 120-foot-by-40-foot building. The factory employed approximately 200 workers and operated for over 20 years—from 1905 until 1927, when it was destroyed by fire. The factory was located adjacent to the site of the current fire station. Henry Boynton is the teamster in the wagon delivering the bags of leather. (Courtesy G. Robert Merry.)

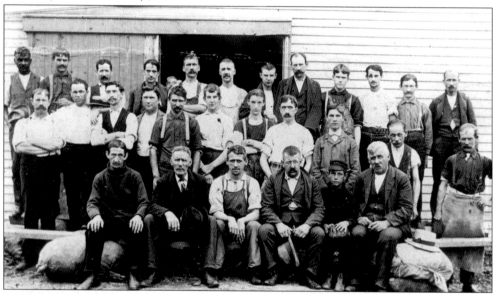

A WORK CREW AT THE F.L. BURKE WOOD HEEL COMPANY ON MAIN STREET AND RAILROAD AVENUE (BURKE'S CORNER), C. 1900 PHOTOGRAPH. The employees seen here are, from left to right, the following: (front row) ? Eng, Joseph Hines, John Burke, Moss Burke, Harland Burke, and Elijah Burke; (middle row) Alvah Stockbridge, William Henley, C.F. Haley, S. Williams, Alphonso Reed, unidentified, Wes Smith, H. Hebb, Aury Morong, Lon Spiller, and unidentified; (back row) Albert Frances, Elmer Durgin, James Rogers, unidentified, R. Matthewson, ? Burke, three unidentified workers, Jack Hammond, unidentified, and Lew Brown. (Curtis F. Haley Collection; courtesy Eva L. Haley.)

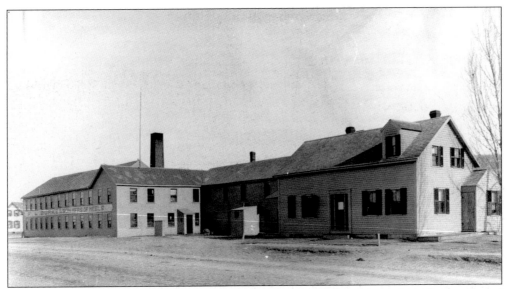

THE F.L. BURKE & SON FACTORY, 1902 PHOTOGRAPH. This factory manufactured wood heels and later became the site of McCarthy's Filling Station. The Moses Ballard House, shown to the right of the factory, was struck by lightning in the 1960s and was destroyed by the fire. (A.O. Rogers Collection; courtesy Rowley Historical Society.)

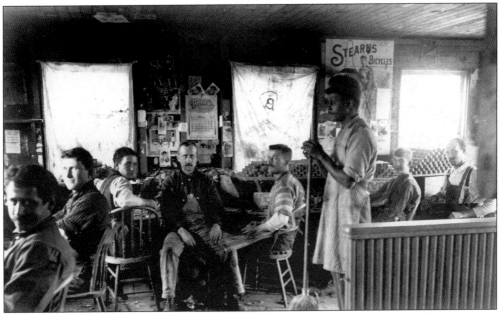

THE INTERIOR OF THE E.W. BURKE WOOD HEEL FACTORY'S PASTE ROOM, 1897 PHOTOGRAPH. Seven workers are shown at their stations in the Paste Room. Note the stacks of wooden blocks along the outer wall that are being shaped into heels. (A.O. Rogers Collection; courtesy Rowley Historical Society.)

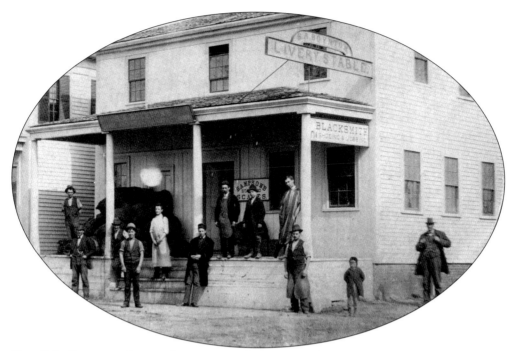

THE S.A. BOYNTON LIVERY STABLE AND BLACKSMITH SHOP ON MAIN STREET, C. 1880S PHOTOGRAPH. This site later became the location of Rowley's present town hall, built in 1904. Boynton ran the store, a shoe shop, and a livery stable there in the 1800s. The Rowley Post Office was located in the store from 1857 to 1886. A fire destroyed the building complex in 1902. (Courtesy G. Robert Merry.)

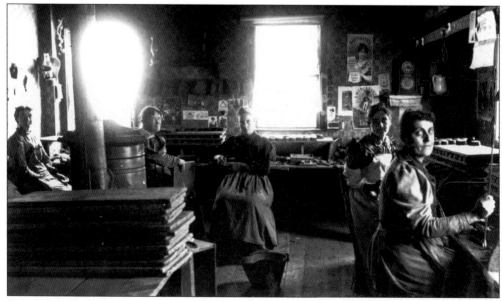

THE INTERIOR OF THE AUGUSTUS BOYNTON HEEL SHOP'S PASTE ROOM, 1897 PHOTOGRAPH. Note the five women employees pasting leather to the wood heels at their work stations and the stack of wood heel trays next to the pot-bellied stove to the left. (A.O. Rogers Collection; courtesy Scott Nason.)

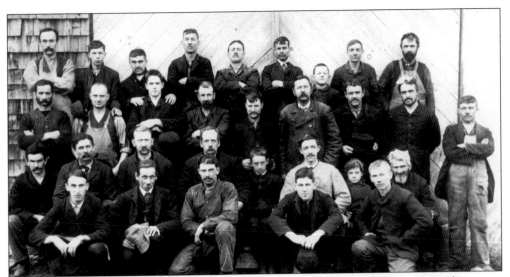

THE S.A. BOYNTON LEATHER SHOP EMPLOYEES, 1888 PHOTOGRAPH. Note the young children in the photograph. The employees seen here are, from left to right, the following: (first row) Howard Bradstreet, Alfonzo Spiller, Charles Lunt, Thomas Roberts, and Philip Dukeshire; (second row) James Perley, Henry Wade, Arthur Savage, Augustus Boynton, Bennett Boynton, George Batchelder, Mamie Spiller, and Tom Spiller; (third row) ? McLaughlin, Frank Bradstreet, Alton Jaques, Herbert Jewett, John Stewart, John Jewett, Arthur Cobb, Harry Jaques, and John Carter; (fourth row) Daniel Ferguson, Lewis Kneeland, Charles Rogers, John Hurley, Edward Dillon, Sam Collins, William Hammond, William Kent, and Albert Hodgdon. (Photograph by Mason Carpenter; courtesy G. Robert Merry.)

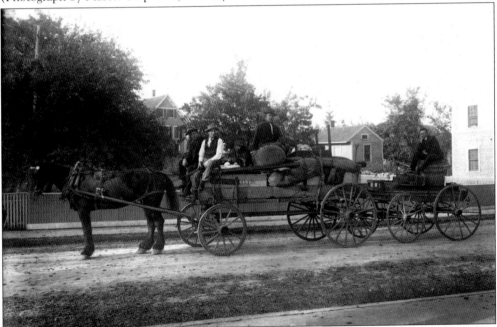

MOVING DAY IN ROWLEY ALONG SUMMER STREET, C. 1900 PHOTOGRAPH. These two wagons, tied together, move products. This photograph was taken from the town common. (Charles Houghton Collection; courtesy Rowley Historical Society and Doris V. Fyrberg.)

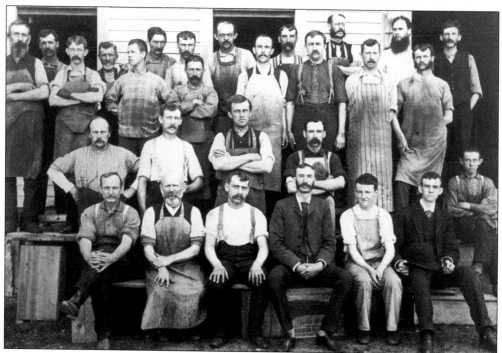

THE HENDERSON SHOE FACTORY EMPLOYEES, 1885 PHOTOGRAPH. The shoe factory was established in 1868. The Henderson Block Building also housed the post office and the S.F. Knowles Grocery Store. The second floor was used as a meeting hall and a shoe shop. The employees seen here are, from left to right, the following: (first row) Jacob Kent, ? Burbank, James Cook, F. Henderson, Daniel Curran, and Henderson's nephew; (second row) Richard Gray, E.A. Daniels, Henry Hobson, William Reilly, and Steve Kent; (third row) Rufus Knox, unidentified, Austin Kelley, two unidentified workers, John Boynton, Frank Merrill, and unidentified; (fourth row) Charles Cook, ? King, Daniel Pike, unidentified, Charles Thompson, Arthur Cook, Austin Millett, ? Kelly, and ? Pickard. (Courtesy G. Robert Merry.)

A GIANT SHOE ADVERTISING ROWLEY'S FLOURISHING SHOE INDUSTRY, c. 1900 PHOTOGRAPH. The early inhabitants of Rowley have, from the beginning of the town, been interested in the manufacture of shoes and leather goods. It became a major industry that employed a large proportion of the adult population. (Charles Houghton Collection; courtesy Rowley Historical Society and Doris V. Fyrberg.)

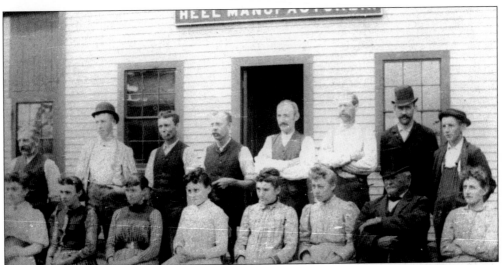

A Group outside the Milton Ellsworth Heel Manufacturing Company, c. 1900 Photograph. The building is located on Wethersfield Street opposite Bradford Street and is a cottage industry at the rear of the Ellsworth House. Seen here are, from left to right, the following: (front row) Grace (Creig) Bradstreet, Florence Smith, Nettie Brown, Mary Hardy, Etta Pike, Ellen (Perty) Hardy, Simion Ellsworth, and Elizabeth (Perley) Smith; (back row) Edwin H. Adams, Harry Goss, Henry Wade, Leander Johnson, John A. Marshall, Frank Littlefield, William Elwell, and Everett Pike. (Courtesy G. Robert Merry.)

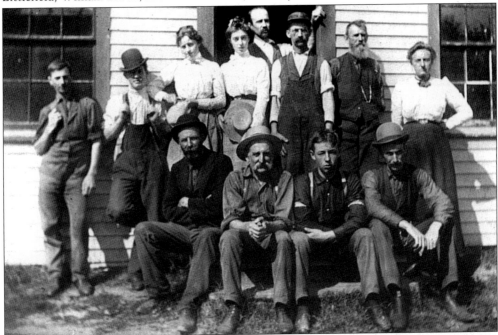

Employees outside of the Milton Ellsworth Heel Manufacturing Shop on Wethersfield Street, c. 1890 Photograph. The employees seen here are, from left to right, the following: (front row) Bertrum Jewett, Edward Adams, Everett Gilford, and Howard Bradstreet; (back row) John Perley , ? (Snappa) Leavitt, Abbie Bradstreet, Maud Bradstreet, Carroll Miller, Henry Davenport, Herb Jewett, and Elizabeth Smith. (Courtesy G. Robert Merry.)

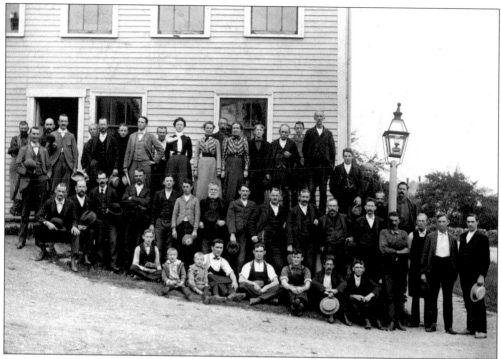

A GROUP IN FRONT OF WILLIAM C. FOSTER'S SHOE SHOP ON SUMMER STREET, 1905 PHOTOGRAPH. Owner Harland C. Foster is located on the far left, third row, holding a derby hat. This company was established in 1850 and continued the operation for over 100 years. Note the oil lamppost to the right. (Courtesy Doris V. Fyrberg.)

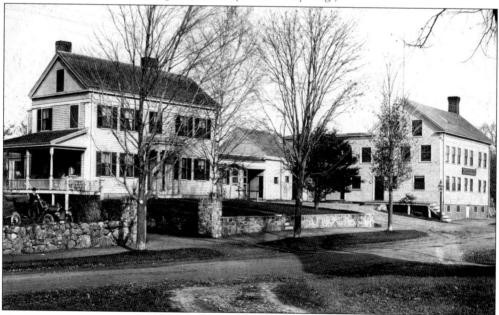

THE HOME AND SHOP OF W.C. FOSTER ON SUMMER STREET, C. 1900 POSTCARD. Harland Foster is shown seated in the automobile to the left. This was Rowley's second automobile at the time the picture was taken. (Courtesy G. Robert Merry.)

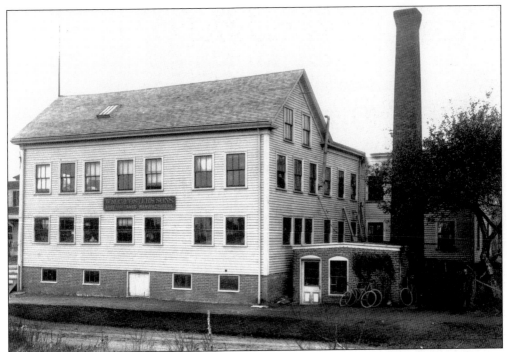

FOSTER'S SHOE SHOP ON SUMMER STREET, C. 1900 PHOTOGRAPH. In its more than 100 years of operation, Foster's Shoe made the finest of women's fancy dress shoes, as well as those for children and men. The shop also specialized in custom handmade boots for fisherman, lumberman, and farmers. Foster's Shoe produced hip boots and soles so thick that pegs about an inch long were used to fasten them. The shop also produced leather aprons for fishermen to wear when dressing fish and other aprons for the village blacksmith. (Courtesy Doris V. Fyrberg.)

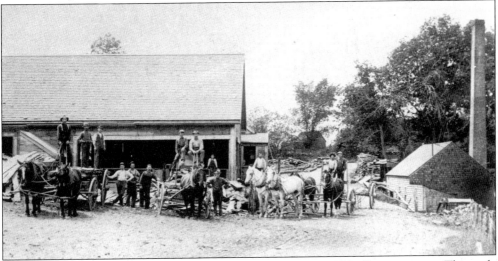

THE STICKNEY DUMMER SAWMILL ON THE MILL RIVER, C. 1890S PHOTOGRAPH. This early sawmill played an important role in the town's history. During the American Revolution, Jedediah Stickney produced cutlasses, spears, and scythes for the army. The mill had previously been a cloth mill in 1733. Note the 13 mill employees with their wagonloads of lumber. (Curtis F. Haley Collection; courtesy Eva L. Haley.)

N. N. DUMMER,

DEALER IN ALL KINDS OF

Pine and Oak Lumber,

BOXES AND SHOOKS MADE

TO ORDER.

Custom Sawing Promptly Executed.

All Orders directed to

Wellington Hiller, Georgetown, Mass.

Will Receive Prompt Attention.

AN N.N. DUMMER ADVERTISING CARD, C. 1890. The card indicates the products sold by Dummer at his sawmill. Shooks, as noted on the card, are the staves and heads of a wood cask. (Courtesy Nathaniel N. Dummer.)

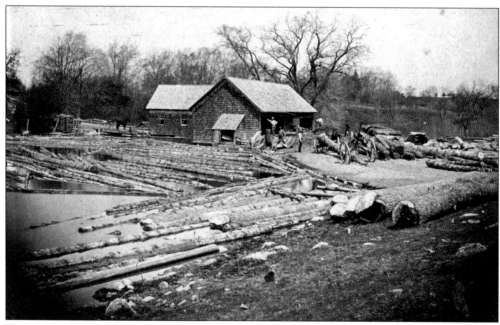

THE DUMMER SAWMILL ON THE MILL RIVER, LOCATED ON DODGE ROAD, C. 1880S PHOTOGRAPH. Note the size of some of the large logs prior to being brought into the sawmill. A primitive horse-drawn logging truck is shown in the center. (Courtesy Nathaniel N. Dummer.)

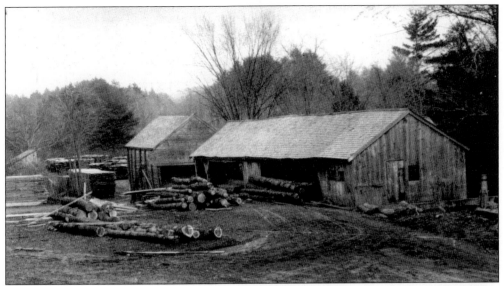

THE PHINEAS A. DODGE SAWMILL, A WATER-POWERED SAWMILL ON THE MILL RIVER, C. 1910 PHOTOGRAPH. The sawmill was established by Thomas Dickinson in 1661. Phineas Dodge, who was also one of the most prominent businessmen in the community, bought a portion of the sawmill from Dickinson in 1772. He was also a selectman and a member of the state legislature. The remains of the early sawmill still exist, and descendants of Phineas A. Dodge, the Herrick family, operate a modern sawmill on the site today. (Courtesy Doris V. Fyrberg.)

PHINEAS A. DODGE

ROWLEY. MASS.

DEALER IN

PINE AND OAK LUMBER

Shingles. Slabs, Sawdust

Custom Sawing Solicited

Post Office Address, Rowley, R. F. D., Millwood, Mass.

A PHINEAS A. DODGE ADVERTISING CARD, C. 1900. This card illustrates Dodge's wood products and custom sawing. (Courtesy G. Robert Merry.)

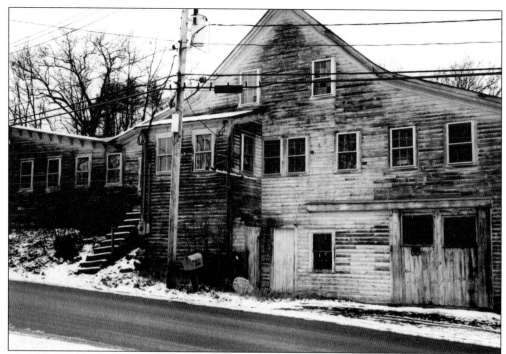

THE DANIELS WAGON FACTORY ON DANIELS ROAD. Moses E. Daniels established his wagon factory in 1868 and sold the building with a blacksmith shop to George E. Daniels around the turn of the century. Daniels installed the first steam-powered engine in his shop in Rowley. (Courtesy Edward J. Des Jardins.)

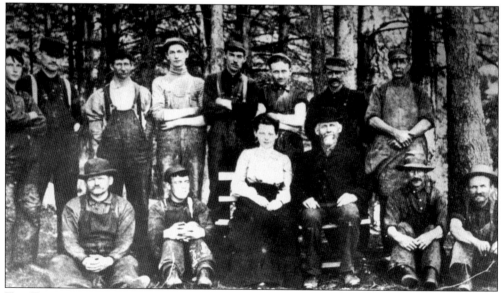

THE EMPLOYEES OF THE DANIELS WAGON FACTORY, C. 1920 PHOTOGRAPH. Seen here are, from left to right, the following: (front row) Fonie Daniels, Arthur Hiller, Louise McCormick, George E. Daniels, Frank Frost, and Andrew Ricker; (back row) Roy Hiller, Fred Hardy, John Daniels, George Lawler, Job McCormick, Harry Hardy, Edward Ricker, and Eldridge Redey. (Courtesy Edward J. Des Jardins.)

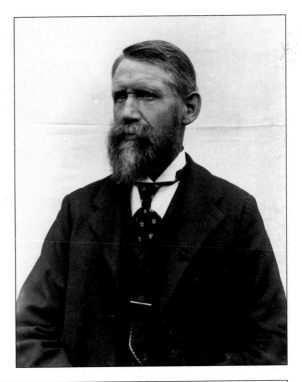

GEORGE E. DANIELS, OWNER OF THE WAGON FACTORY ON DANIELS ROAD AT THE TURN OF THE CENTURY, C. 1902 PHOTOGRAPH. Daniels employed approximately 15 workers at the factory in the manufacturing of custom-made wagons until 1931. The company did a thriving business until motorized vehicles were introduced. It was then sold to John F. Daniels, who continued the operation making truck bodies. John's son Roland operated a furniture business until the early 1960s. (A.O. Rogers Collection; courtesy Rowley Historical Society.)

A GEORGE E. DANIELS ADVERTISEMENT FROM *THE TROLLEY SOUVENIR AND GUIDE BOOK*, C. 1900. The factory manufactured heavy express, ice, milk, and platform wagons; carts; stone-jiggers; heavy wheels; oak and elm hubs; and bent sled runners, including sleds and pungs. It also featured a Daniels patterned end board used for ice wagons. Daniels's other inventions included a cutting block and the four-wheel dump cart. His wagons used the very best lacquers, paints, and lettering and were trimmed in real gold leaf. (Courtesy Nathaniel N. Dummer.)

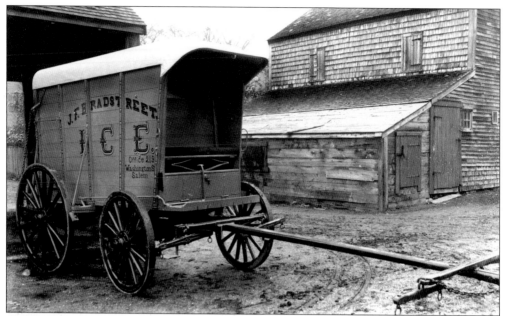

A J.F. BRADSTREET CUSTOM-MADE ICE WAGON, 1897 PHOTOGRAPH. This ice wagon was manufactured by the Daniels Wagon Factory. (A.O. Rogers Collection; courtesy Rowley Historical Society.)

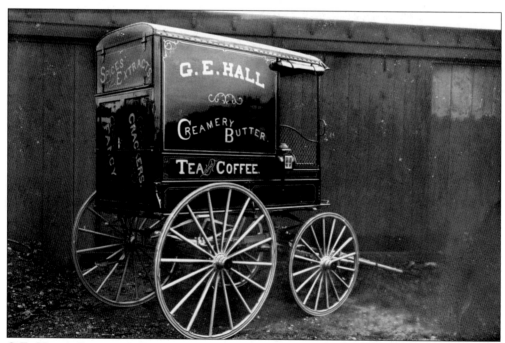

G.E. HALL'S PEDDLER'S WAGON, 1897 PHOTOGRAPH. This wagon was custom made by the Daniels Wagon Factory on Daniels Road. Hall sold tea, coffee, creamery butter, fancy crackers, and spices and extracts. (A.O. Rogers Collection; courtesy Rowley Historical Society.)

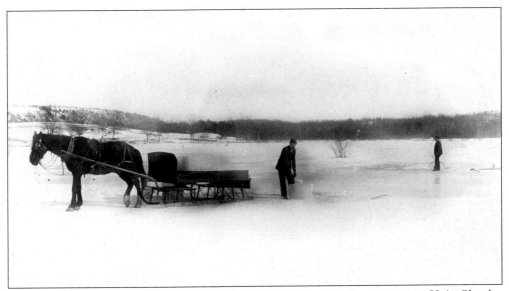

THE LAST DAY OF ICE-CUTTING ON THE LOCAL POND, 1897 PHOTOGRAPH. H.A. Chaplin and Edward Richardson cut ice, approximately 18 inches thick, and load it onto the nearby sleigh. Note the ice tools used in the cutting process. The horse-drawn sleigh is a Daniel's Wagon Factory product. (A.O. Rogers Collection; courtesy Rowley Historical Society.)

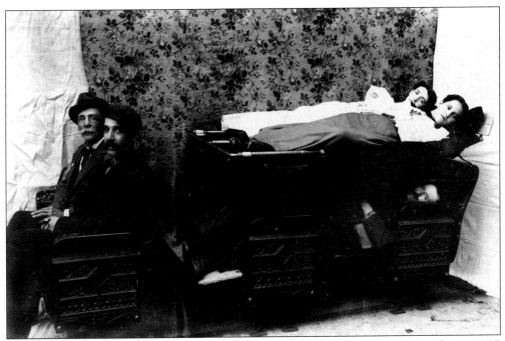

LORENZO BRADSTREET, INVENTOR OF THE BRADSTREET TRAIN SLEEPING CAR, 1897 PHOTOGRAPH. Bradstreet is pictured to the far left, demonstrating how the sleeper unit is converted. His home was located on Main Street, where he had his work studio. This invention eventually led to the development of the Pullman sleeping car. (Charles Houghton Collection; courtesy Doris V. Fyrberg.)

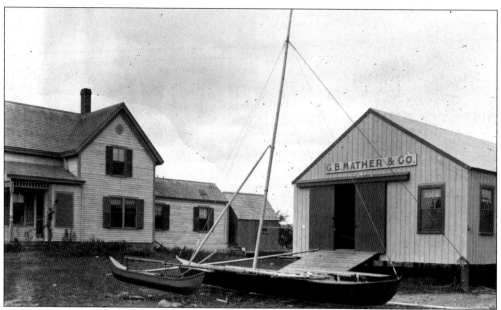

C.B. MATHER & COMPANY BOAT BUILDERS ON RAILROAD AVENUE, 1899 PHOTOGRAPH. The boat shown in the photograph is called a Malay and is manufactured by the Mather Company. It has an outrigger to one side. (A.O. Rogers Collection; courtesy Rowley Historical Society.)

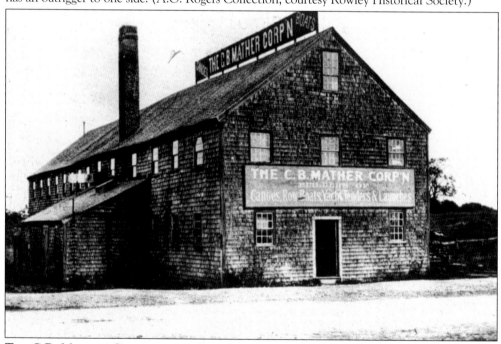

THE C.B. MATHER CORPORATION, BUILDERS OF CANOES, ROWBOATS, YACHTS, TENDERS, AND LAUNCHERS, 1909 POSTCARD. The business started on Railroad Avenue and later moved to Central Street. The building was originally a leather tannery and later became the Star Roller Skating Rink in the 1880s. The company operated in Rowley for approximately 12 years. The building burned down in 1906, and Mather's Boats then moved to Newburyport. (Courtesy G. Robert Merry.)

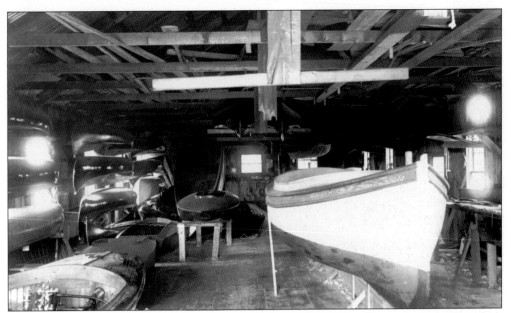

THE INTERIOR OF THE C.B. MATHER BOAT COMPANY, 1900 PHOTOGRAPH. The shop manufactured all kinds of boats—both power and sail—up to 50 feet in length. The company is credited with installing the first motor in a boat used in Essex County (see boat in lower left). (A.O. Rogers Collection; courtesy Rowley Historical Society.)

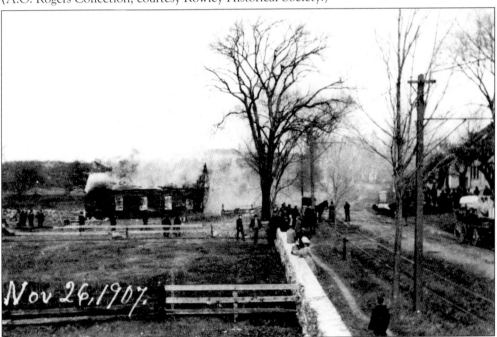

Nov 26, 1907.

WILLIAM PRIME'S BOAT SHOP ON FIRE, 1907 PHOTOGRAPH. On November 26, 1907, a fire broke out and destroyed the entire boat shop, located on Central Street across from Prime's General Store. At this time, without an organized fire department, Rowley had to wait for assistance from the neighboring town to battle the blaze, but it was too late to save the building. (Courtesy G. Robert Merry.)

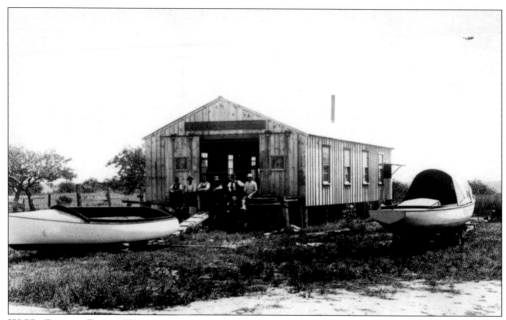

W.H. PIERCE BOAT WORKS ON RAILROAD AVENUE, 1909 POSTCARD. The building was located across the street from the former C.B. Mather Boat Company. Boats and employees are shown gathered at the front of the Boat Works. (Courtesy Elizabeth Hicken.)

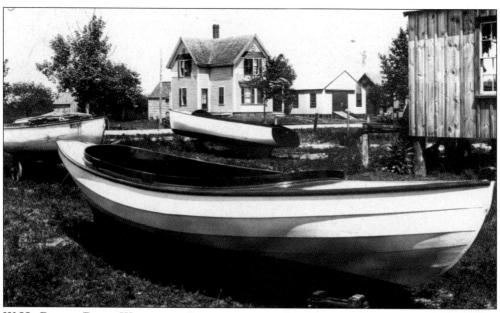

W.H. PIERCE BOAT WORKS ON RAILROAD AVENUE, 1909 POSTCARD. Shown here is a detailed view of the finished boats ready for shipment. (Courtesy Elizabeth Hicken.)

Four

EARLY FARMING AND SALT MARSHES

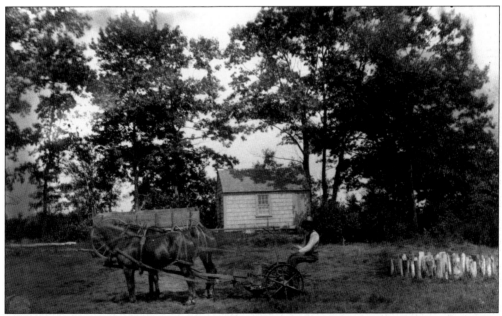

SALT MARSH HAYING AT H.H. MATHER'S MARSH LOWER CAMP, 1896 PHOTOGRAPH. The team of horses mows in the Stackyard Road area. The town of Rowley contains within its borders more than 1,840 acres of tidal marsh. Note the hay staddles to the right of the mower. The staddles are cedar posts placed in a circle to stack salt marsh hay until ready for use. (A.O. Rogers Collection; courtesy Rowley Historical Society.)

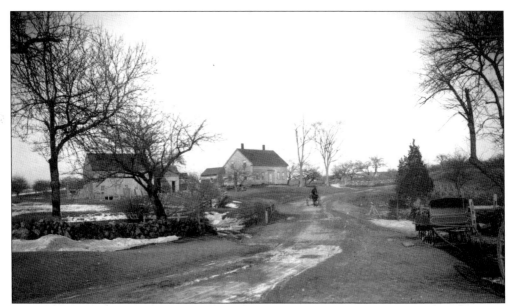

THE WILLIAM WALLIS FARM ON HAVERHILL STREET AND ROUTE 1 (CHAPLINVILLE), 1897 PHOTOGRAPH. The house and barn complex was removed to build the Market Place Shopping Plaza. (A.O Rogers Collection; courtesy Scott Nason.)

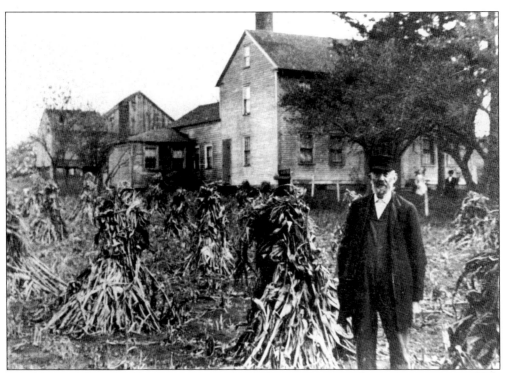

THE HARRIS HALE HOUSE AND BARN ON MAIN STREET, C. 1900 PHOTOGRAPH. Harris Hale stands in the foreground with cornstalks stacked up on each side. (Curtis F. Haley Collection; courtesy Eva L. Haley.)

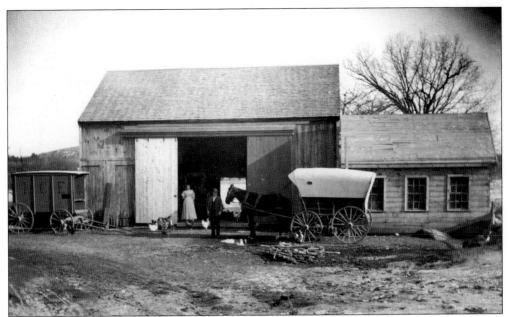

THE H.A. CHAPLIN FARM ON HAVERHILL STREET WITH PROSPECT HILL IN THE BACKGROUND, JANUARY 1897 PHOTOGRAPH. Note the ice wagon to the left and the covered wagon to the right. H.A. Chaplin and his wife are shown in front of the barn door entrance. Chaplin cut ice on the pond at the rear of the barn, with his ice wagon parked nearby. (A.O. Rogers Collection; courtesy Rowley Historical Society.)

THE AMOS SAUNDERS FARM ON WETHERSFIELD STREET, 1897 PHOTOGRAPH. This early farmhouse, formerly known as the John White House, was built in the 1700s by John White. Amos Saunders is pictured in the wagon on the right, while his son is in the one-horse shea to the left. Note the wooden hand pump with a drinking cup and the hay wagon in the background. (A.O. Rogers Collection; courtesy Scott Nason.)

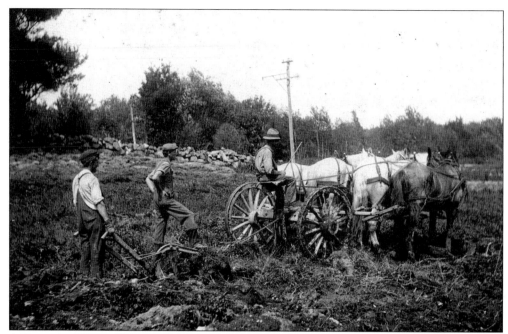

A Plowing Horse Team at Dummer's Farm on Central Street, c. 1900 Photograph. Note the unusual four-horse team working the plow. This area was known as Pollipod Field. A pollipod is a type of fern known to grow in the area. (Courtesy G. Robert Merry.)

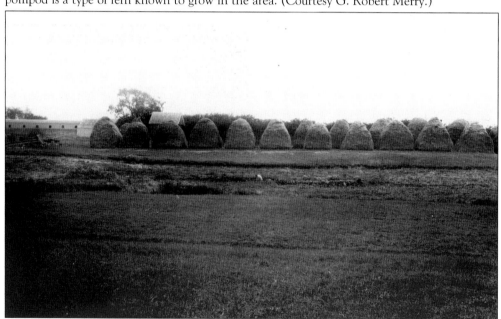

The Haystacks at Charlie L. Dole's Farm on Summer Street, c. 1905 Photograph. The Foster-Dole House was built in 1805 by Lt. Daniel Foster on the original lot granted to Richard Wicom. Two huge dairy barns have graced this property. The first barn burned down in 1838. Another was built to take its place and has since been demolished. Note the number and size of the haystacks at the edge of the field. (Charles Houghton Collection; courtesy Rowley Historical Society and Doris V. Fyrberg.)

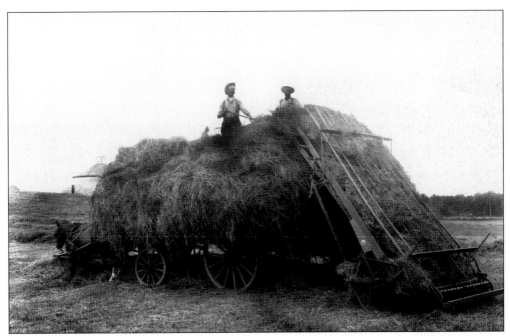

LOADING HAY AT THE N.N. DUMMER FARM ON CENTRAL STREET, C. 1910 PHOTOGRAPH.
Note the new mechanical hay loader at the end of the hay wagon. The unusual round barn is
seen in the background to the left. (Charles Houghton Collection; courtesy Rowley Historical
Society and Doris V. Fyrberg.)

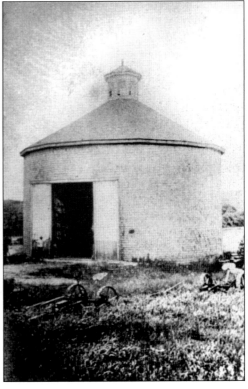

THE FAMOUS ROUND BARN AT THE JOSEPH
DUMMER FARM ON CENTRAL STREET, C.
1915 PHOTOGRAPH. This barn is the only
one of this type located in the area. To
visualize the size of the structure, compare
the height to that of the farmer at the barn
entrance. The height to the barn peak is
approximately 55 feet and the barn diameter
is also approximately 55 feet across. Ron and
Esther Perley later purchased the property.
(Courtesy Doris V. Fyrberg.)

THE TODD DAIRY FARM COMPLEX, OWNED BY FRANK PAYSON TODD, ON THE EAST SIDE OF MAIN STREET, C. 1918 PHOTOGRAPH. Known as the Thomas Gage Esq., House, this structure was built in 1790 and was the home of Thomas Gage, Rowley town clerk from 1822 to 1837. He was also the author of *The History of Rowley*, published in 1840. The estate came down to the Todd family in 1848. The Todd family members have been active in public affairs over the

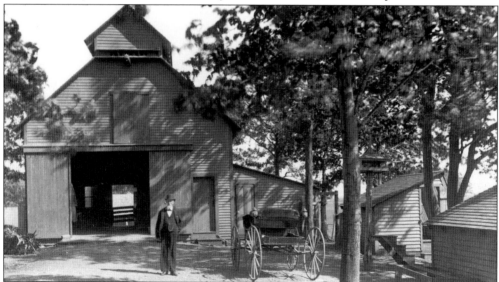

THE H.H. MATHER BARN BORDERING THE ROWLEY MARSHES ON STACKYARD ROAD, 1896 PHOTOGRAPH. Mather's friend Mr. Tibbets is shown in the photograph. The house and barn, built in the early 1890s, still exist today and are the home of former selectman Wendell Hopkins. (A.O. Rogers Collection; courtesy Scott Nason.)

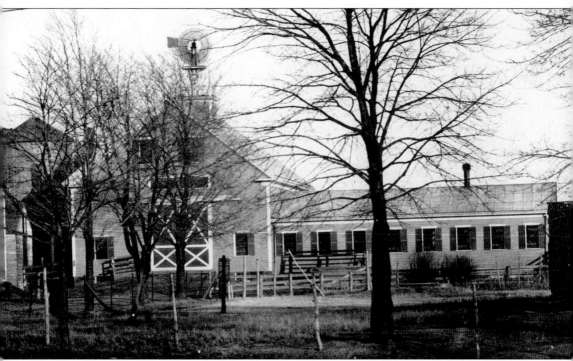

years, including among them a trustee of Governor Dummer Academy, a town selectmen, a member of the legislature, and the town moderator. For many years, the 225-acre farm (approximately 75 acres of pasture, 75 acres of marsh land, and 75 acres of upland) was one of the largest dairy farms in the area. It presently remains in the family as an antique and flea market business. (Courtesy Rowley Historical Society.)

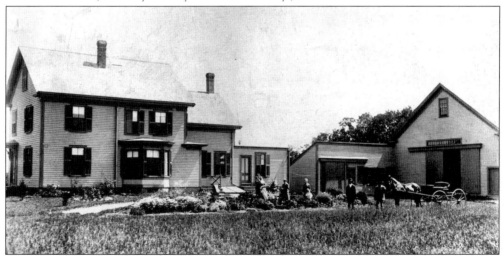

THE JACOB T. SMITH FARM, HOUSE, AND BARN COMPLEX ON HAVERHILL AND BRADFORD STREETS, C. 1900 PHOTOGRAPH. Built in 1882, the complex is shown here with the Richardson family. It was later known as the Buck Dairy Farm and was then purchased by Frank Goodwin. John and Virginia Parker converted the dairy farm into a restaurant called the Eagle House and later the Chanticleer, which has now been extensively restored as the new Eagle House Restaurant by William Markos. (Courtesy Doris V. Fyrberg.)

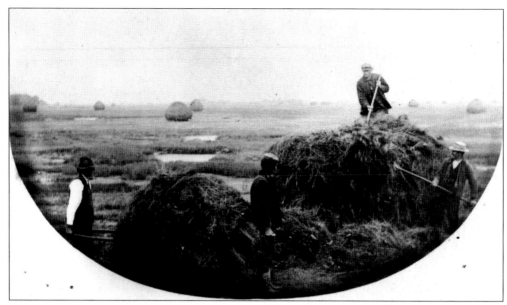

CONSTRUCTING SALT MARSH HAYSTACKS IN THE ROWLEY MARSHES, C. 1890 PHOTOGRAPH.
Note the two workers on the right with hay poles, carrying hay to top off the stack—and the hundreds of existing haystacks in the background—on Rowley's portion of the Great Salt Marsh. Rowley has more than 1,840 acres of marshes—more than 10 percent of the entire marsh area in Essex County. (Courtesy Rowley Historical Society.)

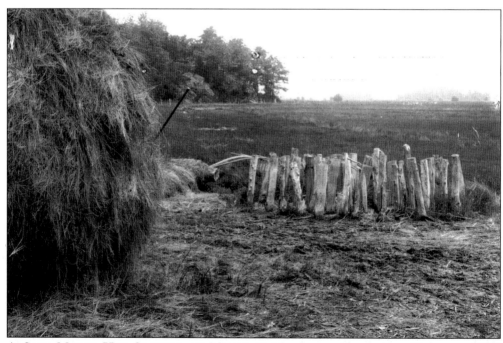

A SALT MARSH HAY STADDLE AT MATHER'S MARSH ON STACKYARD ROAD, C. 1890
PHOTOGRAPH. Staddles were made of large cedar stakes driven into the marsh, protruding about two feet, and placed about one foot apart. The average staddle was 12 feet in diameter and contained from one to three tons of hay. (Courtesy Doris V. Fyrberg.)

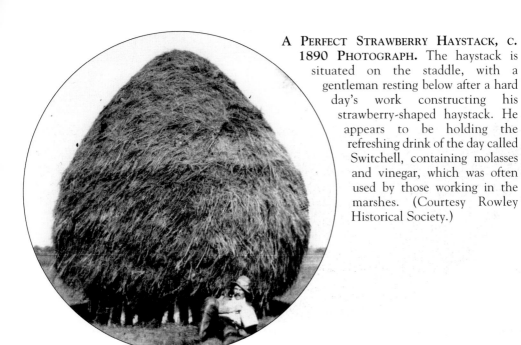

A PERFECT STRAWBERRY HAYSTACK, C. 1890 PHOTOGRAPH. The haystack is situated on the staddle, with a gentleman resting below after a hard day's work constructing his strawberry-shaped haystack. He appears to be holding the refreshing drink of the day called Switchell, containing molasses and vinegar, which was often used by those working in the marshes. (Courtesy Rowley Historical Society.)

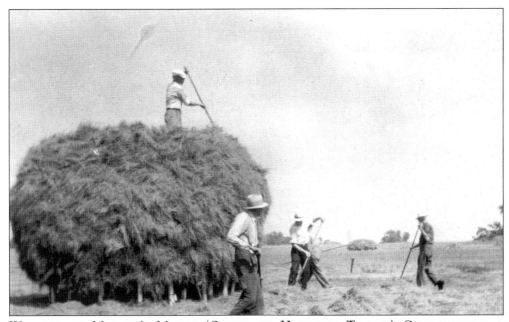

WORKERS AT MATHER'S MARSH (OWNED BY HARRISON TENNEY) CONSTRUCTING A HAYSTACK, 1942 PHOTOGRAPH. Stanley Hills stands on the haystack while Albert Tenney, Harrison Tenney, and "Pa" Hills rake the hay. (Courtesy Louise T. Mehaffey.)

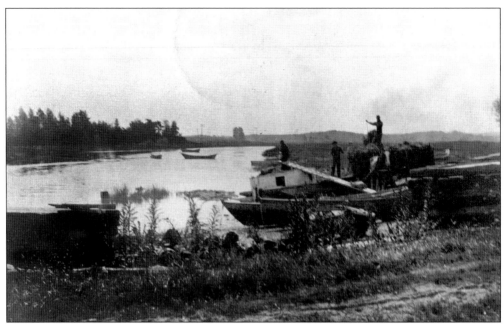

THE WAREHOUSE LANDING ON THE ROWLEY RIVER, 1894 PHOTOGRAPH. Workmen unload salt marsh hay from their gundalows at the old Warehouse Landing. (Courtesy Gertrude W. Carlton and Rowley Historical Society.)

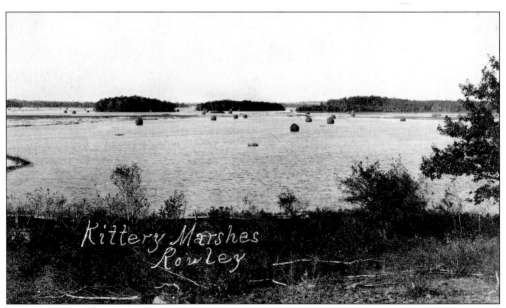

THE KITTERY MARSHES ON THE EAST SIDE OF OX PASTURE HILL, 1910 POSTCARD. Note the saltwater marshes at flood tide and how the many haystacks remain dry (above the water line) on the staddles. (Courtesy G. Robert Merry.)

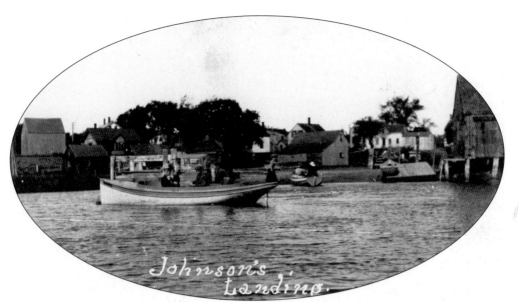

JOHNSON'S LANDING ON THE ROWLEY RIVER, 1909 POSTCARD. Note the steam-driven boat in the center; it appears to be a product of Pierce Boat Works, located on Railroad Avenue. The early Rowley Depot is on the left, and the houses built along Railroad Avenue can be seen in the background. (Courtesy G. Robert Merry.)

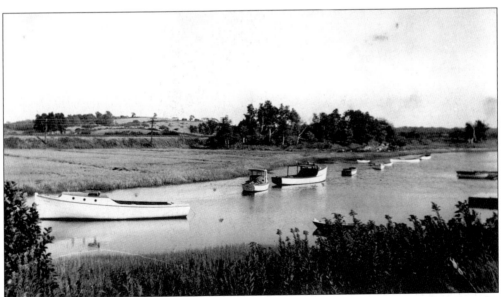

THE BOATS AT ROWLEY LANDING, C. 1940s POSTCARD. Period boats are anchored at the Warehouse Landing. Railroad tracks run in the background through the Rowley marshes. (Courtesy G. Robert Merry.)

DUCK HUNTERS AT THE STACKYARD ROAD CAMP, 1898 PHOTOGRAPH. Gentlemen with double-barreled shotguns are out hunting for the day; their driver can be seen on the right. The prize catch for the day is "one unlucky duck." Note the hay banking along the base of the camp to provide added insulation from winter weather. (A.O. Rogers Collection; courtesy Rowley Historical Society.)

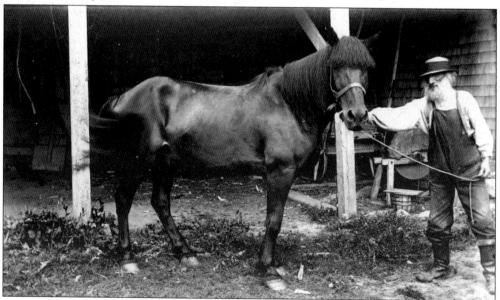

H.N. HAYWARD OF MAIN STREET AND HIS HORSE CHARLIE, 1897 PHOTOGRAPH. This photograph was taken at the Ipswich Bluffs, a popular vacation spot for Rowley residents. Hayward was the proprietor of Hayward's Store, located in Rowley's Village Center. Note the early sleigh and grinding stone located in the barn. (A.O. Rogers Collection; courtesy Rowley Historical Society.)

Five

SCHOOL DAYS

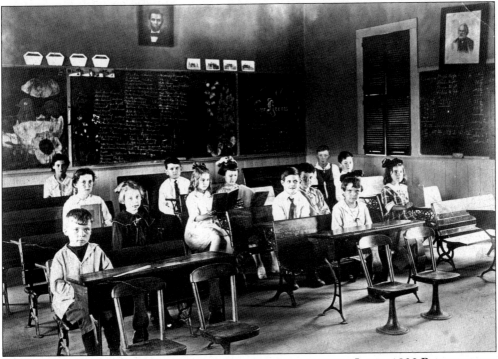

THE INTERIOR OF THE EAST END SCHOOLHOUSE ON SCHOOLHOUSE LANE, 1922 PHOTOGRAPH.
Constructed in 1881 and in use until the 1930s, the building was moved to Main Street and later became the residence of Ellery Maker Jr. Prior to 1930, Rowley had six neighborhood schools: the Millwood School on Haverhill Street, the Clay Lane/Hillside School, the East End School on Main Street, the Turnpike School, the Rabbit Hill School, and the Center School (built in 1904 as an elementary school). The students shown here are, from left to right, the following: (first row) Sidney Maker and Marion Grundstrom; (second Row) Eva (Maker) Watts, Chandler Todd, William Chase, and Phyllis Morong; (third row) Alice Pillsbury, Virgene (Hamilton) Jewett, unidentified, and Gerald McCarthy; (fourth row) unidentified, Frank Grundstrom, and Almond Maker. (Courtesy Jean Garnett.)

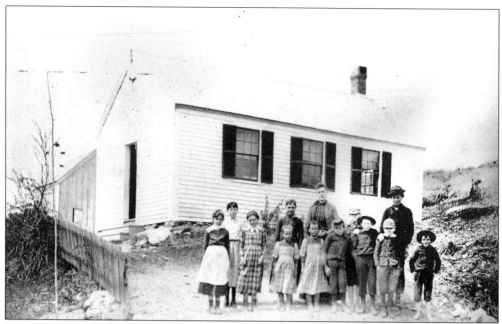

THE HILLSIDE SCHOOL ON CLAY LANE, C. 1880S PHOTOGRAPH. This school was one of the several district schoolhouses located throughout Rowley. Pictured here are, from left to right, the following: (front row) Ethel Chase, Eva Howe, Maude Wiley, Mabel Wiley, James Allen, David Kent, and William Dummer; (back row) Eva Lunt, Louise Hale, teacher Miss Annie Perkins, Eugene Chase, and John Dole. (Courtesy Nathaniel N. Dummer.)

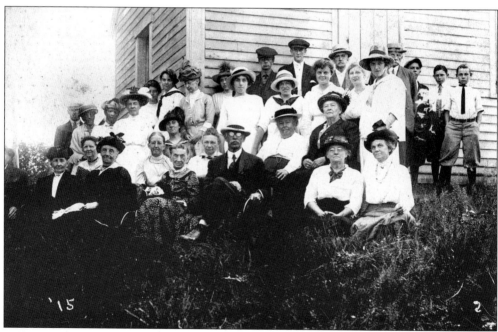

A CLASS REUNION AT THE HILLSIDE SCHOOLHOUSE ON CLAY LANE. This class reunion for Hillside School graduates was held in 1915. (Courtesy G. Robert Merry.)

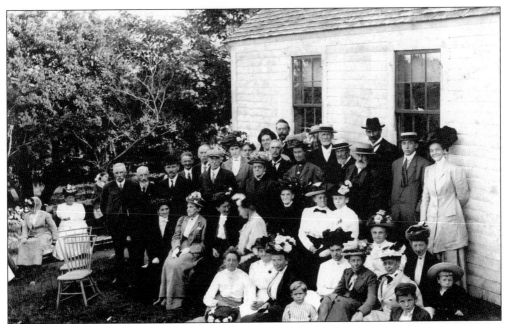

A CLASS REUNION AT THE HILLSIDE SCHOOLHOUSE. Seen here is a 1920 class reunion at the Hillside School. (Courtesy G. Robert Merry.)

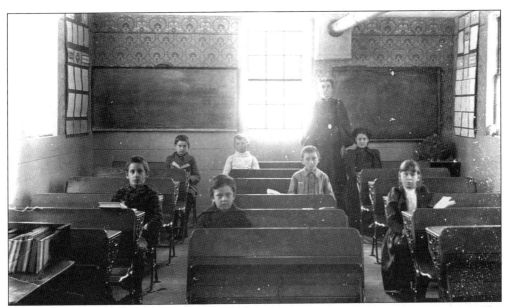

THE INTERIOR OF THE TURNPIKE SCHOOL ON MORPHEW AVENUE, 1897 PHOTOGRAPH. The teacher standing at the rear of the classroom is Sarah O'Brien. The Turnpike Schoolhouse is now used as a residence. (A.O. Rogers Collection; courtesy Scott Nason.)

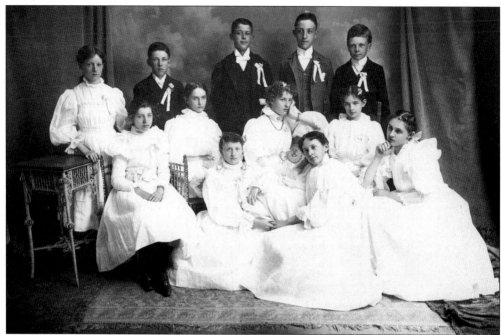

THE ROWLEY GRAMMAR SCHOOL, 1897 PHOTOGRAPH. This photograph was taken in front of town hall. The students seen here are, from left to right, the following: (front row) Alice Jewett, Maude Bishop, and Louise Dow; (middle row) Jennie Hale, Helen Smith, Stella Adams, and Reta Johnson; (back row) Mattie Allen, Wentworth Thomas, Chester Stockbridge, Raymond Jackson, and William Dummer. (Courtesy Nathaniel N. Dummer.)

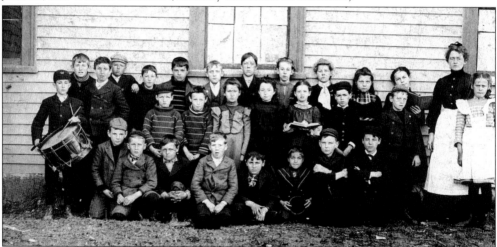

THE ROWLEY GRAMMAR SCHOOL AT THE OLD CENTRAL FIRST DISTRICT SCHOOL, 1902 PHOTOGRAPH. The students seen here are, from left to right, the following: (front row) Robert Marshall, George Perley, Warren Whitten, Frank Fay, Raymond Richards, George Rogers, Alton Cheney, and Ralph Mehaffey; (middle row) drummer Willie Stetson, Chester Mehaffey, Harold Peabody, Elmer Brown, Evelyn Cook, Eva Marshall, Katherine Bailey, Francis Riley, Francis Todd, and Rachel ?; (back row) Seth Elwell, Herman Worthley, ? Leavitt, Frank Cook, Warren Sanborn, Chester Pickard, Margaret Cook, Anna May Johnson, Laura Lunt, Fanny Foster, and an unidentified teacher. (Courtesy Doris V. Fyrberg.)

70

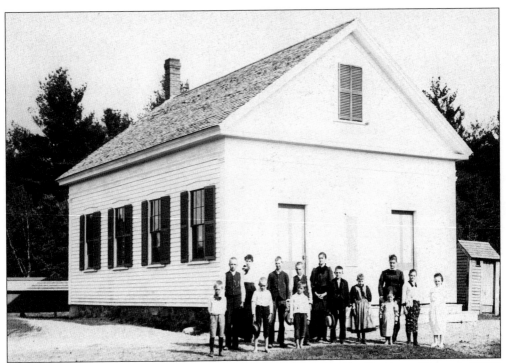

A GROUP AT THE MILLWOOD SCHOOL ON HAVERHILL STREET AND BOXFORD ROAD, C. 1900 PHOTOGRAPH. Note the ladder house on the left to the rear of the school and the outdoor plumbing to the right. (Courtesy G. Robert Merry.)

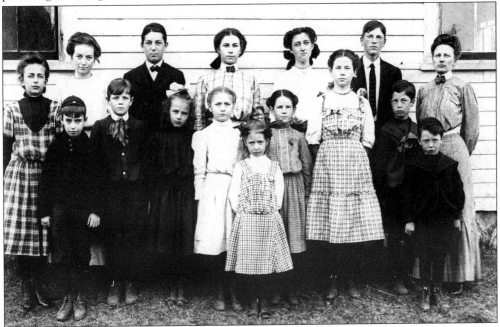

THE MILLWOOD SCHOOLHOUSE, 1910 PHOTOGRAPH. Multiple grades of children located in the Millwood district are seen here. In the back row on the right is teacher Ida Bankcroft. (Courtesy G. Robert Merry.)

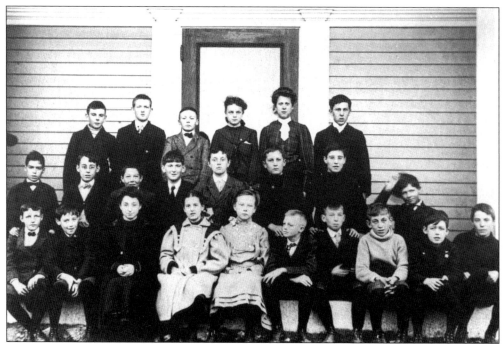

THE NEW 1904 CENTER SCHOOL ON CENTRAL STREET, C. 1910 PHOTOGRAPH. Seen here are, from left to right, the following: (front row) two unidentified, Eva Mehaffey, two unidentified, William Foster, Delbert Hurley, Morris Kelley, unidentified, and Ralph Mehaffey; (middle row) unidentified, ? Carpenter, and six unidentified; (back row) Robert Marshall, Edward Sheehan, unidentified, Roland Gray, and two unidentified. (Courtesy G. Robert Merry.)

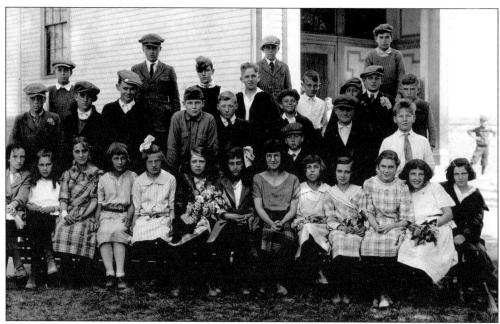

A CLASS AT THE NEW 1904 CENTER SCHOOL. Seen here is a c. 1920s class photograph at the 1904 Center School. (Courtesy G. Robert Merry.)

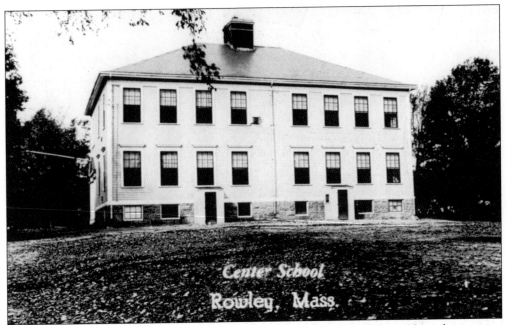

A VIEW OF THE CENTER SCHOOL LOOKING NORTH, 1930s POSTCARD. Note the separate boys' and girls' entrances off of the playground side. (Courtesy Elizabeth Hicken.)

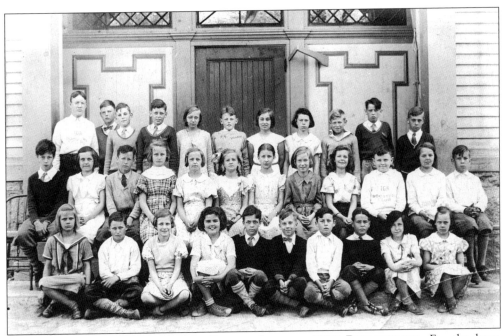

THE FIFTH-GRADE CLASS AT THE CENTER SCHOOL, 1932 PHOTOGRAPH. For the boys, knickers, shirts, and ties were the clothing of the day. (Courtesy G. Robert Merry.)

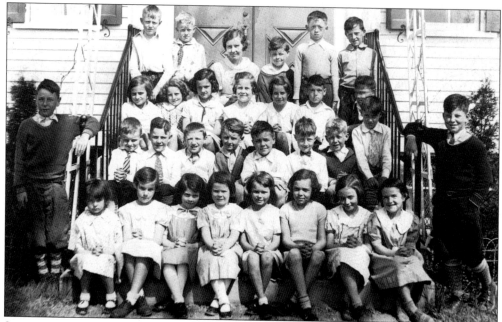

STUDENTS AT THE EZEKIEL ROGERS SCHOOL ON WETHERSFIELD STREET, C. 1930S PHOTOGRAPH. Shown are, from left to right, the following: (first row) William Mehaffey, Phyllis Maker, Mary Marshall, Connie Foley, Frances Foley, Corinne Johnson, unidentified, Marcia Cressey, Anna Sheehan, and Thomas Strangman; (second row) Albert Haley, Joseph Hurtle, Maurice Varmette, ? Kelley, David Hammatt, William Jahnke, Thomas Burke, and unidentified; (third row) Dorothy Wilkins, Eleanor McGlew, Helen McKinnon, Dorothy MacRae, Grace Woodbury, Darold Maker, and Harland Savage; (fourth row) Leo Gerow, unidentified, teacher Miss Kyle, Francis Burns, Harris Savage, and Philip Kent. (Courtesy Rowley Public Library.)

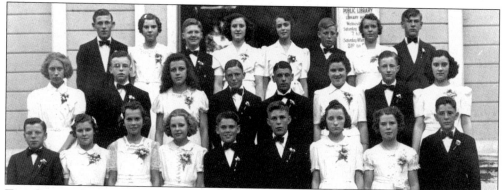

THE CENTER SCHOOL CLASS OF 1940. This photograph was taken on the steps of the town hall on Main Street. The students are, from left to right, as follows: (front row) Charles McCormick, Phyllis (Maker) Sanborn, Corinne (Johnson) Jean, Joanne (Jody) Fuller, Donald Blaisdell, Wendell Warner, Elizabeth "Lil" (Jedrey) Brown, Frances (Foley) McDonald, and Joseph Hirtle; (middle row) Marion Cheney, Albert W. Haley Jr., Maude Kellie, Alfred Babcock, Darold Maker, Anna (Sheehan) Todd, William Jahnke, and Mildred (Seaver) Dummer; (back row) Robert Kellie, Mary (Marshall) Jewett, Burton Cloyd, Frances (Gerow) Hovey, Marcia (Cressey) Haley, Albert L. Smith, Jeannette Reed, and Donald Grover. (Courtesy Rowley Public Library.)

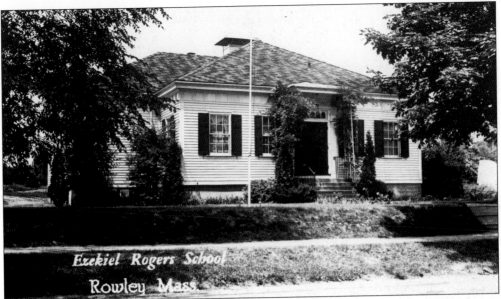

The Ezekiel Rogers School on Wethersfield Street, c. 1930s Postcard. The former grade school built in the Classical Revival style in 1930 now serves as the Rowley Public Library. The library had previously been housed in the town hall until 1966, when the former school was given by the town for use as a public library. It is one of the only Classical Revival buildings remaining in Rowley. (Courtesy Elizabeth Hicken.)

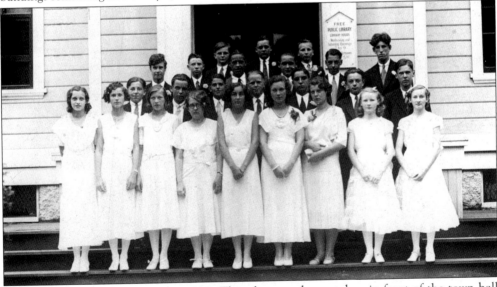

The Center School Class of 1932. This photograph was taken in front of the town hall on Main Street. Seen here are, from left to right, the following: (first row) Elizabeth Dummer, Loretta Johnson, Virginia Morgan, Pauline (Reed) Hardy, Ruth (Johnson) Girard, Amelia Grover, unidentified, Helen (Hayman) Cook, and Mirian Hayman; (second row) Roy Marr, George "Sog" Jedrey, John Lucas, Ollie Olsen, Lenard Cook, Edward Crellin, and unidentified; (third row) "Bud" McGlew, Elmer Brown, unidentified, Rollie Bemis, Ralph "Hack" Mehaffey, and Edgar Short; (back row) Allen Foster, William Woodbury, and unidentified. (Courtesy Frances A. Carey.)

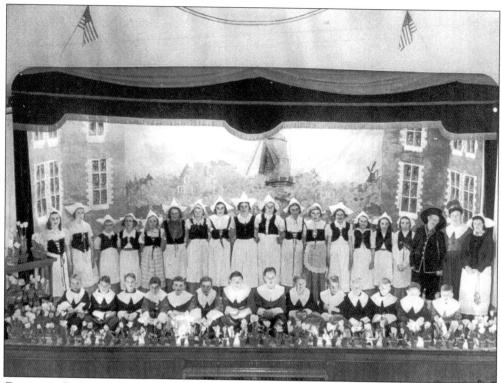

GRAMMAR SCHOOL CHILDREN PERFORMING A DUTCH OPERETTA, 1940 PHOTOGRAPH. This event was performed by the Center School students in the second-floor auditorium of town hall. (Courtesy Doris V. Fyrberg.)

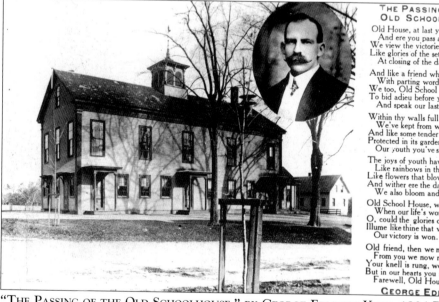

THE PASSING OF THE OLD SCHOOL HOUSE.

Old House, at last your work is done
 And ere you pass away
We view the victories you have won
Like glories of the setting sun
 At closing of the day.

And like a friend who lingers by
 With parting words to tell,
We too, Old School House, linger nig
To bid adieu before you die
 And speak our last farewell.

Within thy walls full many an hour
 We've kept from wordly care;
And like some tender budding flower
Protected in its garden bower
 Our youth you've sheltered there.

The joys of youth have come and gon
 Like rainbows in the sky;
Like flowers that blow at early morn
And wither ere the day be done,
 We also bloom and die.

Old School House, we must pass awa
 When our life's work is done:
O, could the glories of our day
Illume like thine that we might say
 Our victory is won.

Old friend, then we must say good by,
 From you we now must sever;
Your knell is rung, we pass you by,
But in our hearts you never'll die,
 Farewell, Old House, forever.

GEORGE EDMUND KING

"THE PASSING OF THE OLD SCHOOLHOUSE," BY GEORGE EDMUND KING, 1904 POSTCARD. The building was located on Central Street and is now called the Town Hall Annex. (Poem by George Edmund King; courtesy Doris V. Fyrberg.)

Six
MODES OF
TRANSPORTATION

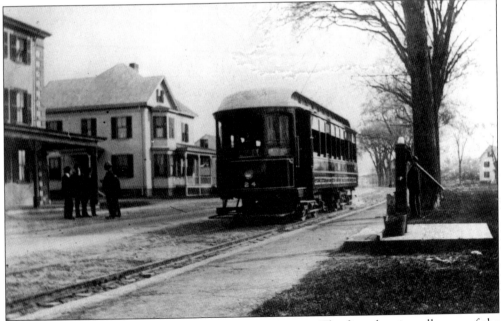

A TROLLEY CAR ON MAIN STREET, 1900 PHOTOGRAPH. The first electric trolley car of the Georgetown, Rowley, and Ipswich Street Railway Company is shown here in front of the old Eagle House Hotel opposite the town common. Prior to the advent of the automobile, trolley routes ran through town from 1900 to 1919. Note the wooden town water pump to the right. (Marian G. Todd Collection; courtesy Frank and Shirley Todd.)

ISSUED BY	I	15	30	45
Georgetown, Rowley & Ipswich Street R'y Co.	II	15	30	45

The ticket contains a table on the right with Roman numerals I–XII and values 15, 30, 45.

ISSUED BY
Georgetown, Rowley & Ipswich Street R'y Co.

For a continuous ride on the cars of the
BOSTON & NORTHERN STREET RAILWAY CO.
From High Street Railroad Crossing to Central Square.

If presented on FIRST car leaving crossing on the date issued after the time shown by punch marks. *Philip M Reynolds* Treasurer.
Form N 182.

11815

	15	30	45
I	15	30	45
II	15	30	45
III	15	30	45
IV	15	30	45
V	15	30	45
VI	15	30	45
VII	15	30	45
VIII		30	45
IX	15	30	45
X	15	30	45
XI	15	30	45
XII	15	30	45

1 2 3 4 5 6 7 8 9 10 11 12 13 14 15 16
Jan Feb Mar Apr May June July Aug Sept Oct Nov Dec — A.M.
17 18 19 20 21 22 23 24 25 26 27 28 29 30 31 — P.

A TROLLEY TICKET FROM THE GEORGETOWN, ROWLEY, AND IPSWICH STREET RAILWAY COMPANY, C. 1900. Note that the ticket allows for a 15-cent ride from Zone 7. (Courtesy G. Robert Merry.)

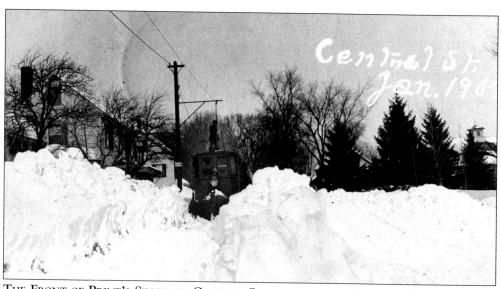

THE FRONT OF PRIME'S STORE ON CENTRAL STREET DURING A JANUARY BLIZZARD, 1904 POSTCARD. Plowing was done to clear the trolley tracks to allow the car to pass. (Courtesy Rowley Historical Society.)

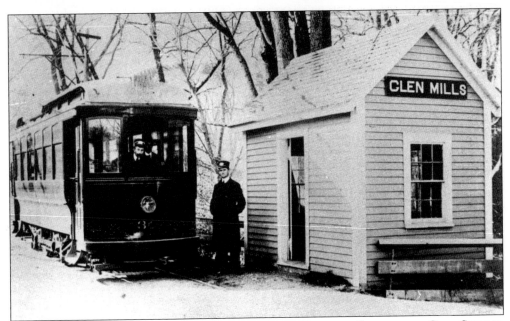

ELECTRIC CAR TROLLEY NO. 32 AT THE GLEN MILLS TRANSFER STATION ON GLEN STREET, C. 1910 POSTCARD. The motorman in the photograph is "Captain" Samuel F. Knowles. Superintendent George W. Pratt stands beside Knowles. The conductor is Percy Oliver. (Courtesy Nathaniel N. Dummer.)

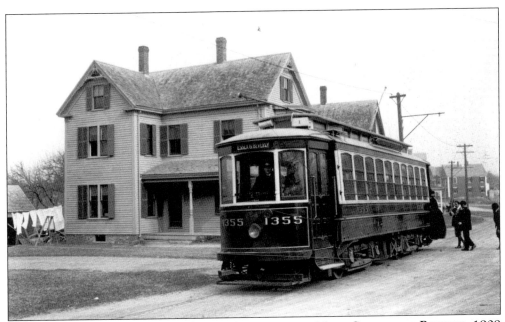

AN ELECTRIC CAR AT THE CORNER OF CENTRAL AND MAIN STREETS IN ROWLEY, 1909 PHOTOGRAPH. Here, an electric car heading toward Ipswich takes on passengers. (Marian G. Todd Collection; courtesy Frank and Shirley Todd.)

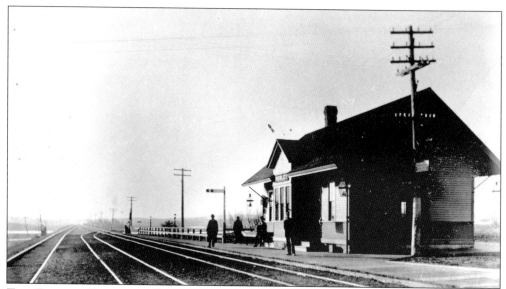

THE ROWLEY DEPOT ON RAILROAD AVENUE, 1896 PHOTOGRAPH. These three tracks, heading toward Ipswich, took passengers from Boston to Portland, Maine. The railroad line started as the Eastern Railroad in 1849 and later came under the control of the Boston and Maine Railroad in 1890. The building was destroyed by fire in 1929. Note the early oil lamps mounted on the station exterior and the flag stop, alerting the train engineer to take on additional passengers. (A.O. Rogers Collection; courtesy Scott Nason.)

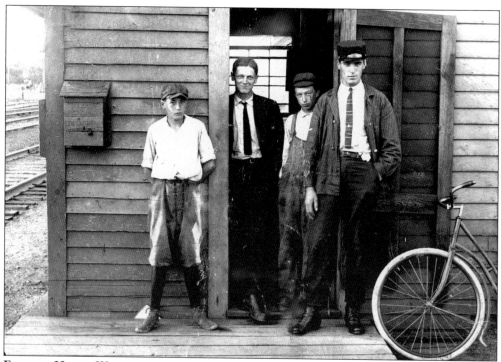

FREIGHT HOUSE WORKERS AT THE ROWLEY DEPOT, C. 1915 PHOTOGRAPH. Freight worker Ralph E. Mehaffey is located to the right. (Courtesy Doris V. Fyrberg.)

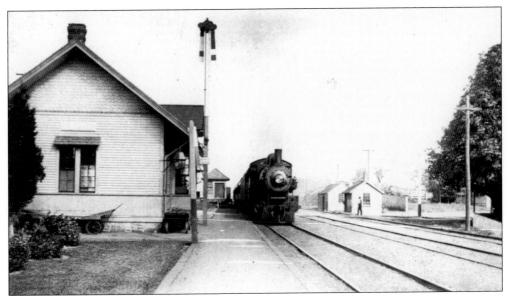

THE EARLY RAILROAD STATION WITH A STEAM TRAIN, C. 1900 POSTCARD. This is a view of the Boston and Maine rail line passing through Rowley. (Courtesy Rowley Historical Society.)

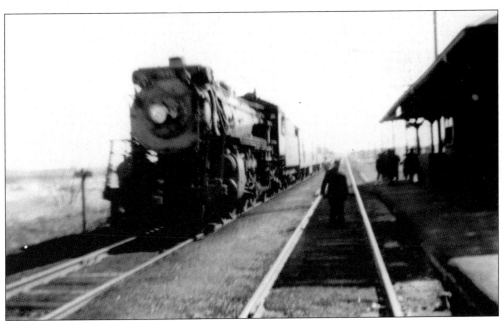

THE LAST STEAM TRAIN GOING THROUGH ROWLEY. This 1951 photograph shows the last steam train to travel through Rowley. (Courtesy G. Robert Merry.)

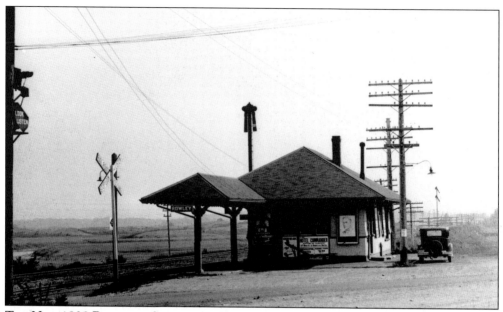

THE NEW 1929 RAILROAD STATION ON RAILROAD AVENUE, 1929 PHOTOGRAPH. This view looks south at the station on Railroad Avenue. (Courtesy Elizabeth Hicken.)

BEAN'S RAILROAD CROSSING ON LOWER MAIN STREET, C.1890S PHOTOGRAPH. This is the site of the present overpass bridge. Note the flagman shown in the center at the crossing. (A.O. Rogers Collection; courtesy Scott Nason.)

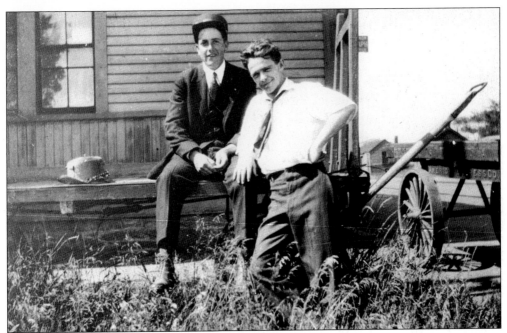

TRAIN CONDUCTOR ARNOLD GOODWIN AND TICKET AGENT FRANK FLETCHER AT THE OLD STATION, 1925 PHOTOGRAPH. Note the American Express freight wagon to the right of the photograph. (Courtesy Jean Garnett.)

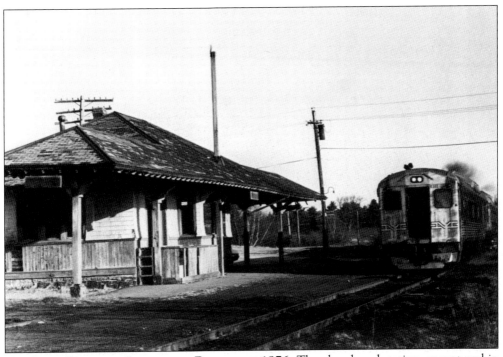

THE LAST "BUDLINER" THROUGH ROWLEY IN 1976. The abandoned station, vacant and in disrepair, is shown to the left. Note the single set of tracks operating at this time. (Courtesy John Grover.)

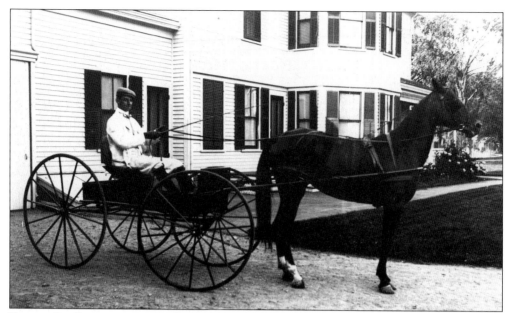

FRANK L. BURKE AT THE CORNER OF INDEPENDENT AND SUMMER STREETS, 1897 PHOTOGRAPH. Frank Burke is shown at home in his wagon with his prized trotting horse. Burke was the owner and proprietor of Burke's Wooden Heel Factory in Rowley and Ipswich. The building is presently the Roberts Funeral Home. (A.O. Rogers Collection; courtesy Scott Nason.)

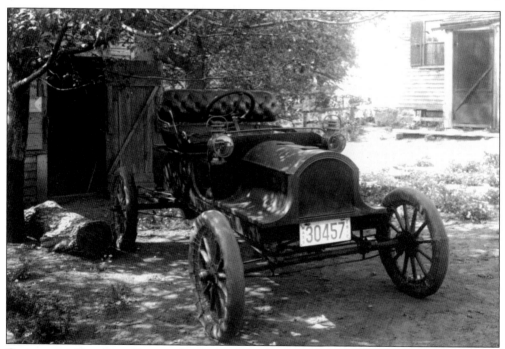

ONE OF THE EARLIEST CARS IN ROWLEY, 1912 PHOTOGRAPH. Note some of the interesting features of the two-passenger Speedster: the oil lights, leather-wrapped wheels, and padded leather wagon seat. The car has a very unusual engine bonnet. (Charles Houghton Collection; courtesy Rowley Historical Society.)

EARLY VANS MAKING DELIVERIES IN TOWN, C. 1920S PHOTOGRAPH. Seen here are Arnold Goodwin (left) and Warren Whitten (Rowley's local butcher) taking a break with their delivery trucks. (Courtesy Jean Garnett.)

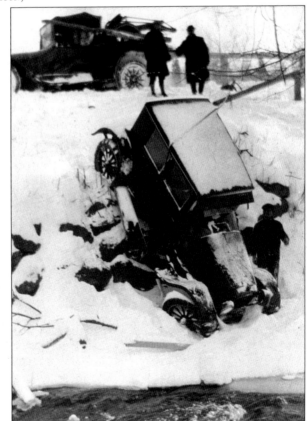

A BAD DAY ON THE ROAD, 1923 PHOTOGRAPH. On January 6, 1923, this unlikely driver had an unfortunate opportunity to see the Mill River in Rowley from a different perspective. Note the vintage wrecker from Grady's Garage offering assistance. (Courtesy G. Robert Merry.)

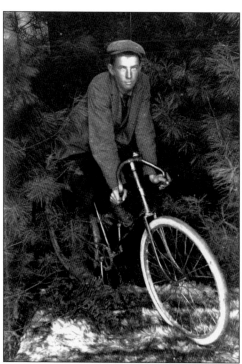

LOCAL RESIDENT ON HIS BICYCLE, 1897 PHOTOGRAPH. Seen here is Norman Kent out for a ride on his bicycle. (A.O. Rogers Collection; courtesy Scott Nason)

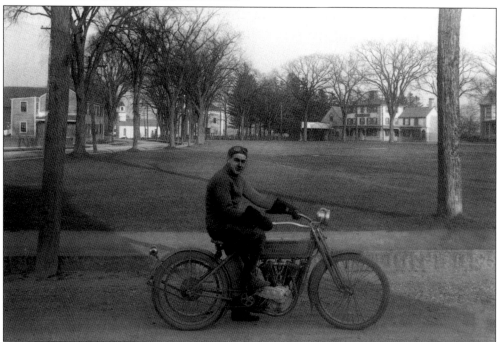

A VIEW OF E. DOUGLAS JEWETT ON INDEPENDENT STREET LOOKING TOWARD MAIN STREET, c. 1910 PHOTOGRAPH. Jewett is shown with his new Harley Davidson motorcycle and the latest riding fashion: leather chaps over his knees, gloves, and goggles. Note the town common and buildings in the background; the Eagle House Hotel (right center) is the only building not there today. (Courtesy Doris V. Fyrberg.)

Seven
GLEN MILLS

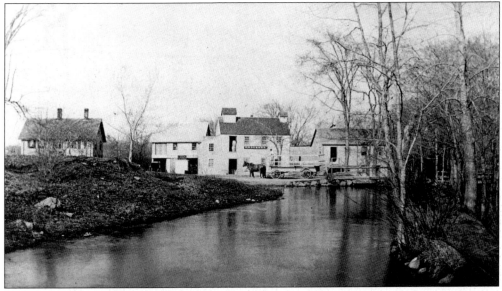

THE ENTIRE STICKNEY-DUMMER MILL COMPLEX, C. 1880S PHOTOGRAPH. The Mill River (previously called Easton's River) furnished water power for numerous mills including the famous clothier's mill, built by John Pearson in 1643 for the fulling of cloth—the first in the colonies. In 1733, Samuel Stickney built a gristmill and, soon after, a sawmill at this site. Purchased by Samuel and Joshua Dummer in 1817, it operated as a sawmill and box factory. Logs were sawed into timber and hauled to Essex for shipbuilders. Boxes made at the factory were used by Foster's Shoe for the shipment of shoes and fishermen's boots. (Courtesy Nathaniel N. Dummer.)

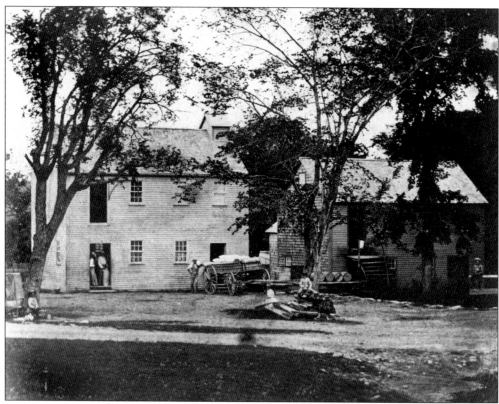

A BOSTON AND MAINE RAILROAD RECEIPT FOR A GRAIN SHIPMENT, SEPTEMBER 28, 1870. The receipt is for one railroad car of oats, weighing 28,000 pounds, for a total cost of $119. (Rowley Historical Society; courtesy Nathaniel N. Dummer.)

THE EARLIEST PHOTOGRAPH OF DUMMER'S MILL LOOKING EAST, IN THE GLEN MILLS DISTRICT, 1875 PHOTOGRAPH. In 1858, N.N. Dummer closed the sawmill operation and incorporated the buildings into a flour business, naming the facility the Glen Mills Cereal Company. Workers are shown unloading a wagonload of raw grain, to be milled into flour. The portion of the mill shown grew in size over the years to constitute a much larger complex.

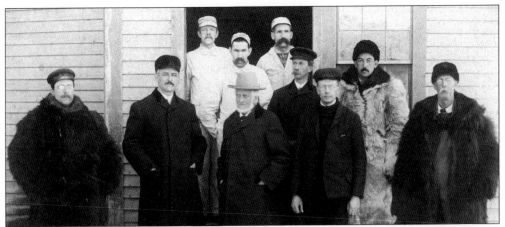

THE GLEN MILLS CEREAL COMPANY WORK CREW WITH THE OWNER, 1906 PHOTOGRAPH. Nathaniel N. Dummer is shown in the center (white beard). The gentlemen wearing the heavy fur coats and boots on each side of the photograph are the teamsters who drove the open wagons four trips a day to the railroad siding to pick up grain. Seen here are, from left to right, the following: (front row) Wendel S. Pace, Arthur W. Peabody, Nathaniel N. Dummer, William Dummer, and Frank Jaques; (back row) Ernest Crosby, Francis Addison, Charles Bemis, Joseph N. Dummer, and Charles Curtis. Mrs. Jaques ran the employee boardinghouse located in the mill complex. (Courtesy Nathaniel N. Dummer.)

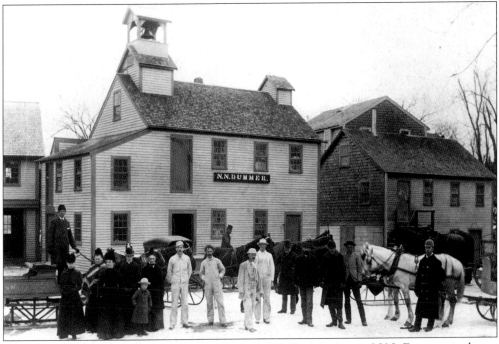

A WINTER SCENE AT THE MILL COMPLEX, C. 1890 PHOTOGRAPH. N.N. Dummer is shown here with family members and some employees. Note the many sleighs in the background. In the center, owner N.N. Dummer dons the derby hat and white beard. Other family members are gathered to the left. The young child is William Dummer. The ladies on the far left are Carrie Dummer and Mrs. E.M. Dummer. On the far right in front of the white horse is Joseph N. Dummer. (Courtesy Nathaniel N. Dummer.)

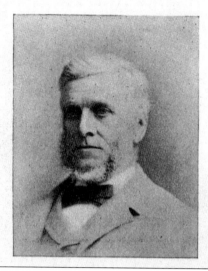

N. N. DUMMER,

ROWLEY, MASS.,

⅋ ⅋ Manufacturer of and Dealer in ⅋ ⅋

Glen Mills Specialties.

Golden Corn Meal, New Process Rye Meal.

True Wheat Meal, Golden Corn Flour,

Improved Graham, or Entire Wheat Flour,

Breakfast Cake Mixture.

AN ADVERTISING CARD OF THE N.N. DUMMER CEREAL COMPANY, C. 1895. In the 1830s, a movement was underway across the country to improve one's health by using whole grain products. Nathaniel N. Dummer perfected the milling of health flours for Dr. Johnson of Educator Cracker fame. With the large variety of grain products offered at the Glen Mills Cereal Company, it had become one of the most prosperous small mills in New England, and crackers and wafers became commonplace in every home. The company had outlets for its products in Newburyport and in Boston. (Courtesy Nathaniel N. Dummer.)

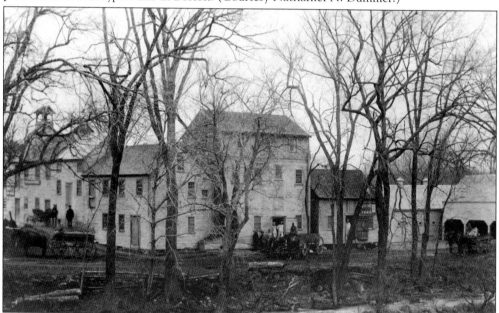

A VIEW OF THE MILL COMPLEX LOOKING NORTH, WITH THE MILL RIVER IN THE FOREGROUND, C. 1900 PHOTOGRAPH. The storage and grinding buildings are to the left. The mill bears elevator capacity to store 14,000 bushels of grain, as well as storage room for manufactured products. Note the carriage house to the right—the only building still existing today. (Courtesy Nathaniel N. Dummer.)

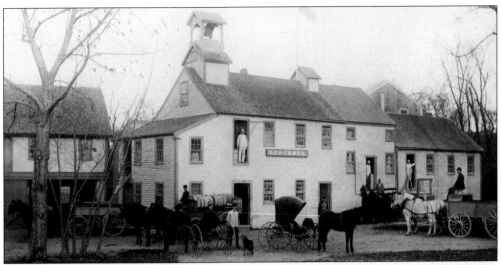

A VIEW OF GLEN MILLS LOOKING EAST, C. 1900 PHOTOGRAPH. Note the bell tower that summoned workers. Shown are a wide variety of wagons with white-uniformed mill workers standing in the doorways. Owner N.N. Dummer, with his white beard, is in the center behind the horse and buggy. The new building addition to the warehouse has been constructed to the right of the flag. (Courtesy Nathaniel N. Dummer.)

GLEN MILLS BREADSTUFFS.

To think well, eat well, and breathe well is to live well and thus

☼ BE WELL. ☼

Order through your Grocer

Golden Corn Meal,
White Corn Meal,
New Process Rye Meal,
Improved Graham or Entire
 Wheat Flour.
N. E. Hominy, Brown Bread
Mixture, Cracked Wheat,
Glen Mills Flour,
White Rye Flour,
Breakfast Cake Mixture,

The name "GLEN MILL"
is a synonym
with PURITY.

N. N. Dummer, ROWLEY, MASS.

AN ADVERTISEMENT FOR GLEN MILLS CEREAL COMPANY BREADSTUFFS IN THE *MERRIMAC VALLEY TROLLEY GUIDE*, C. 1915. Note that the photograph in the advertisement is identical to the one above. The advertisement reads, "To think well, eat well, and breathe well is to live well and thus be well." The products included golden corn meal, white corn meal, new process rye meal, improved graham or entire wheat flour, N.E. Hominy, brown bread mixture, cracked wheat, Glen Mills Flour, white rye flour, and breakfast cake mixture. The document was printed by Advocate Printers in Georgetown, owned by Joseph N. Dummer. (Courtesy Nathaniel N. Dummer.)

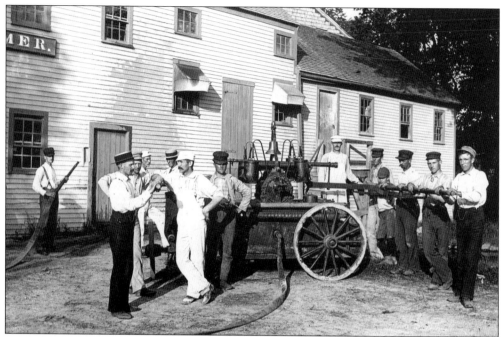

An Early Glen Mills Hand Tub, c. 1910 Photograph. Nathaniel Dummer purchased the Tiger, a Hunnermen end-stroke hand tub, and the hose reel from the Willow Dale Mills in Ipswich. Workers practice in case of fire. The hose nozzle is held by Arthur Peabody. Note the leather fire buckets hanging on stanchions on the hand tub. Some of those assisting were millers dressed in white uniforms. The young boy in knickers is William Dummer. In 1916, fire did break out and destroyed the entire mill complex. The Dummers then moved the Glen Mills business into offices in Newburyport. (Courtesy Nathaniel N. Dummer.)

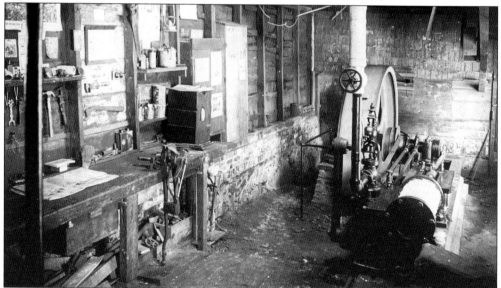

The Interior of the Dummer Mill Engine Room, c. 1890s Photograph. Steam-driven machinery was used to supplement power for the waterwheel when the water level was low. (Courtesy Nathaniel N. Dummer.)

Two Views of the Steam-Powered Rye Thrashing Machine, c. 1898 Photograph. The rye grain was raised by N.N. Dummer on the Judge Tenney Farm near his sawmill. He produced white rye flour and new-process rye meal. During the religious movement of the 1830s, Rev. Sylvester Graham believed salvation could be achieved by exercise, temperance, regular bathing, daily teeth brushing, and course ground flour—which gave rise to the graham cracker and a renewed demand for whole grain, unbelted flour. (Courtesy Nathaniel N. Dummer.)

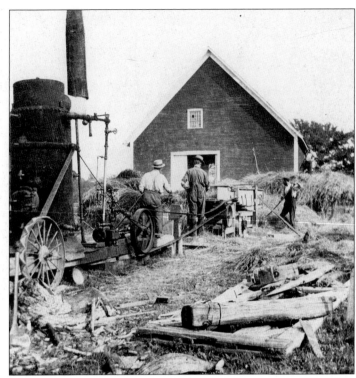

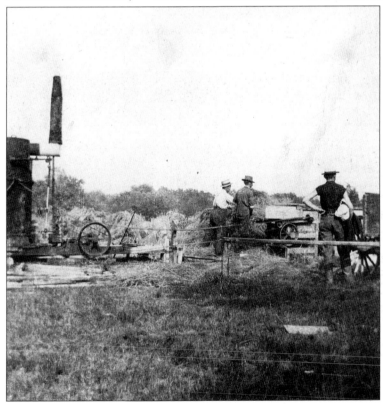

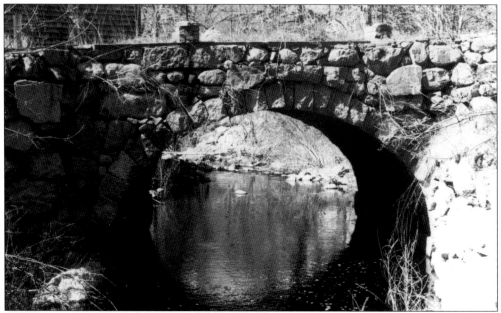

THE KEYSTONE ARCH BRIDGE SPANNING THE MILL RIVER, C. 1642–1643. This early stone arch bridge, over 350 years old, was designed and built by Richard Holmes, who also constructed the dam for the mill complex. It is the oldest bridge of its kind in North America, is constructed entirely of hand-chiseled granite block, and contains no mortar. Bridges such as this one were common in England but were a rarity in New England for another 100 years. The bridge was built for Thomas Nelson in order to get to his planting fields across the road. (Courtesy G. Robert Merry.)

A VIEW LOOKING UPRIVER OF THE GLEN MILLS DAM, C. 1910 POSTCARD. Richard Holmes designed the dam, as well as the Keystone Arch Bridge, in 1643. The dam diverted water to the canal, which ultimately supplied water to the overshot waterwheel and powered the fulling mill, gristmills, and sawmills in the area. (Courtesy G. Robert Merry.)

NATHANIEL N. DUMMER, OWNER OF
THE GLEN MILLS CEREAL COMPANY,
c. 1910 PHOTOGRAPH. The
photograph was taken at Dummer's
home, known as the 1714 Capt. John
Pearson House. This was also the
home of Joseph N. Dummer,
selectman, school committee member,
trustee of Governor Dummer
Academy, and the author of *Land and
Houses of Rowley*. In the background
is an unusual corner cupboard with a
decorative shell design at the top.
(Courtesy Nathaniel N. Dummer.)

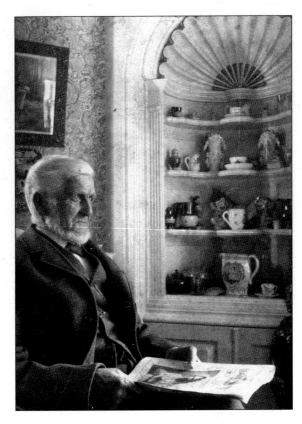

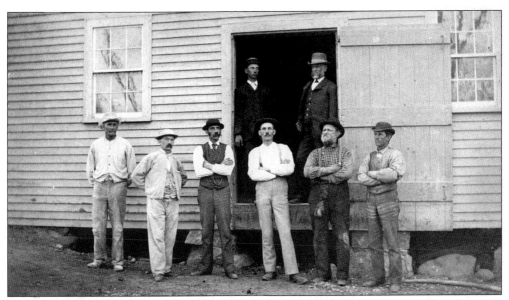

AN EARLY WORK CREW WITH THE MILL OWNERS, c. 1890s PHOTOGRAPH. Seen here are,
from left to right, the following: (front row) Lewis Adams, Gorham Merrill, George Bradstreet,
Henry Durant, and two unidentified men; (back row) owners J.N. Dummer and N.N. Dummer.
(Courtesy Nathaniel N. Dummer.)

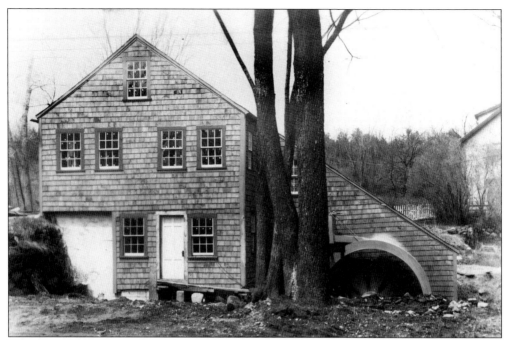

THE GLEN MILLS JEWEL MILL, 1958 PHOTOGRAPH. The jewel mill sits on the site of the old gristmill. Paul W. Parker bought the former mill site in 1942 and built the small mill, which is a copy of the oldest known mill building and includes a waterwheel that is similar to the one Richard Holmes built in 1642. (Courtesy G. Robert Merry.)

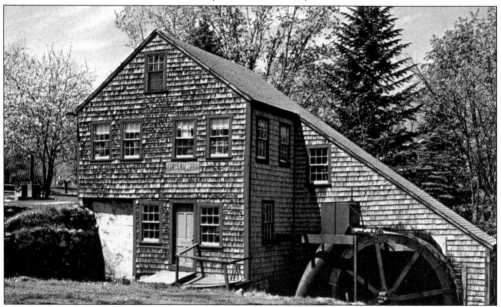

THE GLEN MILLS JEWEL MILL, C. 1960S POSTCARD. In 1942, Paul W. Parker, an engineer who built the mill on the original waterworks, used water power for tumbling, or polishing, gems and ornamental stones in large barrels. The mill is fitted with World War I warship turbines and a 12-foot overshot wheel to power the facility. It is considered the oldest working mill site in America, having been in continuous operation since 1642. (Courtesy G. Robert Merry.)

Eight
THE FENNO ESTATE

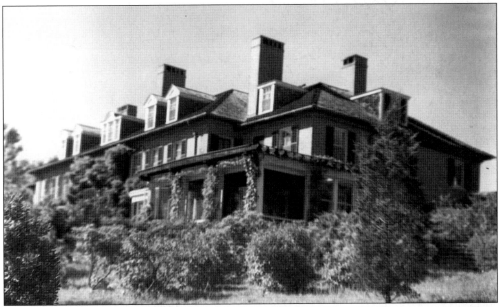

A Front View of the Fenno Estate on Ox Pasture Hill Overlooking the Town Center, c. 1930s Photograph. The Todds were settlers of early Rowley, in the section eventually known as the Fenno Estate. The Fennos purchased part of the Daniel Todd parcel in 1906 and enlarged the estate to 375 acres. Later land purchases brought the total to approximately 600 acres by 1940. The 30-room brick mansion was designed and architecture was overseen by Mrs. Pauline Fenno, who was the daughter of Quincy Adams Shaw, a prominent Boston banker. She also owned the Fairview Home for nurses on Wethersfield Street and was an active philanthropist involved in charitable work at the Massachusetts General Hospital in Boston. In Rowley, she donated the money to install electricity in both the Congregational and Baptist churches. The house was first occupied by the Fennos in 1910, and Mr. Fenno died that same year. In 1954, the estate and 10 acres were sold to Stephen Comley Sr., who refurbished the mansion, and it became Seaview Convalescent and Nursing Home. The second and third generations of Comley sons now own 200 acres, and the complex is presently known as Seaview Retreat Inc. (Courtesy Elizabeth Hicken.)

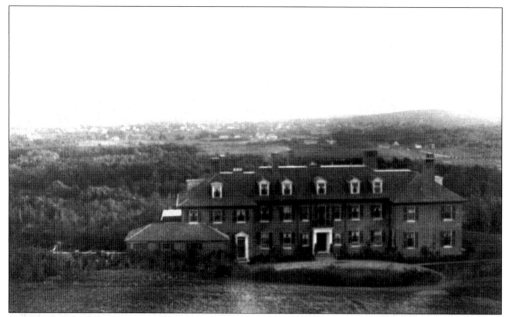

A BIRD'S-EYE VIEW OF THE ESTATE WITH THE ROWLEY VILLAGE IN THE BACKGROUND, C. 1915 PHOTOGRAPH. Mrs. Fenno also designed the weekend guest house called the Bowlery, named for the two bowling alleys that were located on the ground floor. (Courtesy Seaview Retreat Inc.)

THE OBSERVATION TOWER AT THE HIGH POINT OF THE HILL, C. 1915 PHOTOGRAPH. The site gave a commanding view of the surrounding area. A number of other buildings were constructed in the complex, including several homes for the staff, a stable and garage, a tennis house, barns, and very elaborate gardens. (Courtesy Seaview Retreat Inc.)

PAULINE (SHAW) FENNO AND HER DAUGHTER, C. 1915 PHOTOGRAPH. The view was taken from the estate on top of the hill with the drive down and the ocean in the background. The family consisted of four daughters: Pauline, Florence, Marion, and Elizabeth. After Mr. Fenno died, the family lived mostly in Rowley and often traveled to England in the summer. At the end of World War I, they stayed at their home on 238 Beacon Street in Boston in the winter and in Rowley in the summer. (Courtesy Seaview Retreat Inc.)

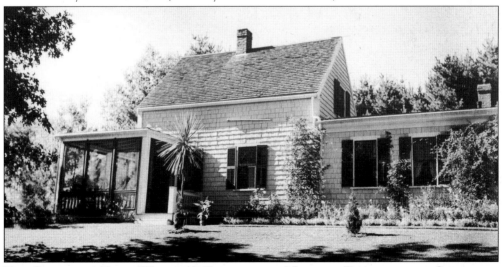

THE SUNNYSIDE FARM WORKERS' COTTAGE ON MANSION DRIVE AT THE CORNER OF KITTERY AVENUE, C. 1930S POSTCARD. The Fennos provided homes for many of the staff. This was the home of Mr. Crellin, one of the workers. The home is privately owned today and has had many additions. (Courtesy Elizabeth Hicken.)

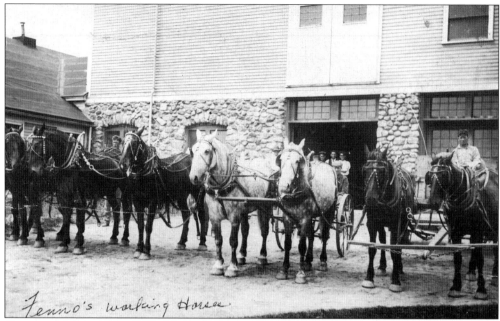

Fenno's working Horses

TEAMS OF WORK HORSES OUTSIDE OF THE BARN, C. 1930S POSTCARD. The Fenno Estate contained a complete farm with workers to help plant and harvest vegetables, fruit, and poultry, as well as a creamery and an ice house (ice was harvested on the large pond). (Courtesy G. Robert Merry.)

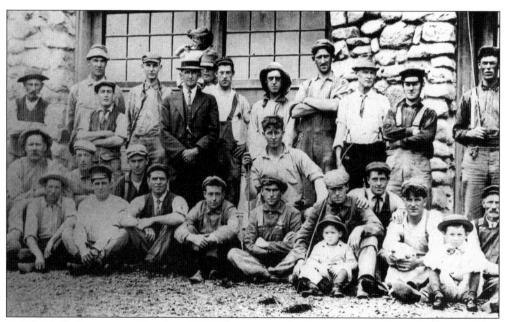

A WORK CREW ON THE ESTATE, 1910 PHOTOGRAPH. Shown here is the work crew in front of the barn. The staff at the main house was made up of 11 people headed by the butler, Helmer Olsen. Eight men worked in the gardens and twelve on the farm. (Curtis F. Haley Collection; courtesy Eva L. Haley.)

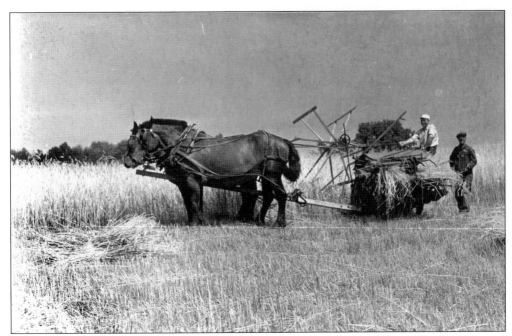

A Reaping Machine Harvesting Wheat on Ox Pasture Hill at the Fenno Estate, c. 1930s Photograph. Russell "Rut" Worthley is shown to the right behind the machine. (Courtesy Elizabeth Hicken.)

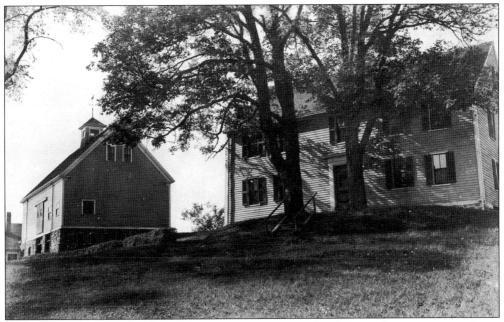

The 1720 Todd Walnut Farm, c. 1930s Postcard. This farm was later incorporated into the Fenno Estate. Since the sale by the Fennos in the early 1950s, the farm has had many uses. Recently, this barn has been converted into a residence. (Courtesy Elizabeth Hicken.)

ACTOR JAMES CAGNEY WITH BUTLER HELMER OLSEN'S TWO-AND-A-HALF-YEAR-OLD GRANDSON DICK OLSEN. In 1946, the Fenno Estate was the site for the filming of the movie *13 Rue Madeline*. The Olsen family was friendly with the Cagneys. (Courtesy Seaview Retreat Inc.)

A SYNOPSIS OF THE MOVIE *13 RUE MADELINE*, FEATURING JAMES CAGNEY AND SHOT ON THE FENNO ESTATE. Shot on the Fenno Estate site, the movie featured actors James Cagney, Richard Conte, Annabella, and Frank Latimore. It was a semi-documentary tale of the careers of four American espionage agents whose mission overseas is to locate a German rocket-bomb launching site in France, so that the Air Corps can bomb it before D-Day. (Courtesy Seaview Retreat Inc.)

Nine

SPECIAL EVENTS AND
CELEBRATIONS

THE 200TH ANNIVERSARY REENACTMENT OF BENEDICT ARNOLD'S 1775 ENCAMPMENT ON THE COMMON, 1975 PHOTOGRAPH. Rowley was part of an international reenactment of Arnold's 1775 expedition to Quebec in September 1975. The encampment, under the command of Maj. Return Jonathan Meigs, occurred on the Training Place, just as it did in September 1775. The dignitaries are, from left to right, the following: (front row) Warren Grover, Joseph Lyons, Doris Fyrberg, Doris Bradstreet, Warren Appell, and Willard Jewett; (back row) Rev. Paul Millen and Rep. David Lane. (Courtesy Doris V. Fyrberg.)

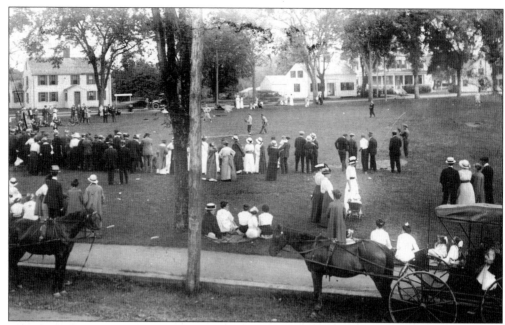

THE FOURTH OF JULY CELEBRATION ON THE TOWN COMMON, C. 1910 POSTCARD. The crowd watches a baseball game in progress. Note the wagons parked beside the common and the early period homes in the background, which still exist today. (Courtesy G. Robert Merry.)

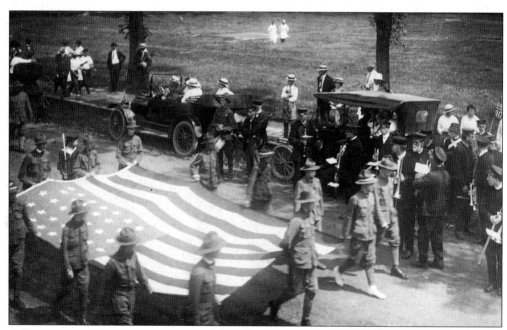

A PARADE AND CELEBRATION ALONG MAIN STREET NEXT TO THE ROWLEY TOWN COMMON, 1911 POSTCARD. The Rowley Brass Band appears on the right. Note the Boy Scout troop carrying the 35-star American flag in the parade. (Courtesy G. Robert Merry.)

A PARADE AND BASEBALL GAME IN PROGRESS ON THE FOURTH OF JULY, 1911 PHOTOGRAPH. Note the Rowley Brass Band on the left and the spectators in their cars parked along the town common. (Marian G. Todd Collection; courtesy Frank and Shirley Todd.)

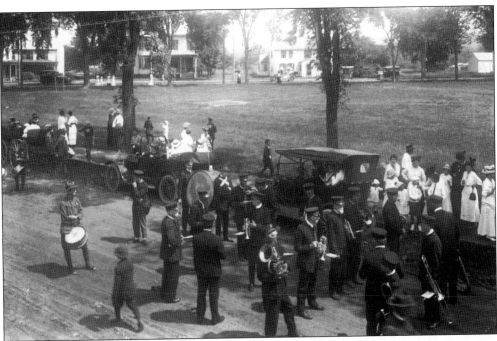

THE FOURTH OF JULY CELEBRATION WITH THE ROWLEY BRASS BAND ASSEMBLING ALONG SUMMER STREET, 1911 PHOTOGRAPH. The spectators wait for the parade to begin. The Eagle House Hotel, built in 1806 and shown on the far left, burned down in 1920. (Marian G. Todd Collection; courtesy Frank and Shirley Todd.)

ROWLEY, MASSACHUSETTS
TERCENTENARY CELEBRATION

August 24 - 25 - 26 and 27, 1939

TOWN COMMITTEE

Hon. Cornelius F. Haley, Chairman
John A. Marshall, Clerk

Frank W. Fletcher
Samuel F. Knowles, Jr.
Rupert S. Morrill
Harlan C. Foster
Miss Gertrude W. Carleton

George E. Pike
Miss Marian G. Todd
Mrs. Knight Dexter Cheney
Albert F. Tenney
Amos E. Jewett

Joseph N. Dummer

SUB-COMMITTEE CHAIRMEN

Rowley Historical Society
 Garden Party
 Miss Marian G. Todd, Pres.

Band Concert
 Amos E. Jewett
 John A. Marshall

Bronze Tablets
 Amos E. Jewett

Colonial Ball
 Mrs. Edith L. Daggett

Tercentenary Parade
 Harvey E. Saunders

Sunday Church Service
 Miss Helen R. Sornborger

Souvenirs
 Milford F. Daniels

Tercentenary Programs
 John A. Marshall

Town Improvement
 Anthony Sheehan

Historical Episodes
 Mrs. Etta E. Hodgdon

Baseball Game
 Sumner C. Bruce

Tree Planting
 Harlan C. Foster

Sports Program
 Randolph W. Emerson

Firemen's Program
 Chief Alexander Good

Tercentenary Banquet
 Mrs. Knight Dexter Cheney

Cannon, "Old Nancy"
 Curtis F. Haley

Markers,
 House lots of Earlier Settlers and
 Old Houses
 Amos E. Jewett

ROWLEY'S TERCENTENARY CELEBRATION, 1639–1939. The celebration took place from August 24 through August 27, 1939. The program seen here lists the town committee and sub-committee chairmen that put on the various events. (Courtesy G. Robert Merry.)

THE 1939 TERCENTENARY CELEBRATION. Marian G. Todd is shown in period costume. She was very active in community affairs as the town's first selectwoman and was re-elected several times. She was also the town's librarian and historian for many years. (Courtesy Elizabeth Hicken.)

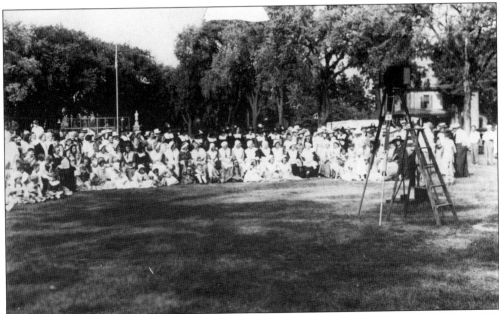

A PANORAMIC PHOTOGRAPH BEING TAKEN ON THE TOWN COMMON DURING THE 1939 TERCENTENARY CELEBRATION. Note the Pilgrim costumes and those in period dress for the pageant. (Courtesy Elizabeth Hicken.)

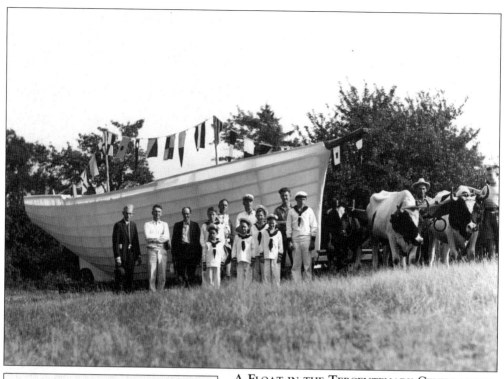

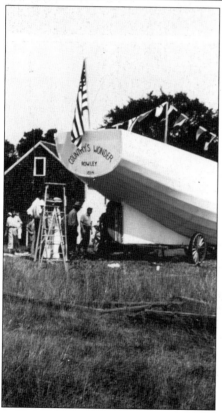

A Float in the Tercentenary Celebration Parade, 1939 Photograph. Shown in the photographs are the builders of the parade float named for the most famous of Rowley's vessels, the *Country's Wonder,* built by Capt. Nathaniel Mighill Perley in 1814. Captain Perley chose the southerly end of the common, two miles from the launching area on the river, to build a 100-ton vessel. At 10 a.m. on the morning of May 10th, 1814, two sets of four oxen wheels were attached to the cradle of the ship and, with 150 yoke of oxen, the *Country's Wonder* was slowly and carefully towed to the landing. So great was the task that the men required liquid refreshment. A cask of rum was supposedly poured into Captain Saunders's well across from Warehouse Lane, and when the ship arrived at the well, "the men refreshed themselves with abandon." The *Country's Wonder* was safely afloat at five in the afternoon after the two-mile journey to the river. Seen above are, from left to right, the following: (front row) Dana Hiller, ? Hirtle, and ? Hirtle; (middle row) William Mehaffey, Joe Hirtle, and Jack Curtis; (back row) Lawrence Bishop, Maynard Haley, Everett Hiller, Jim Hirtle, Ralph Mehaffey, Frances "Red" Knowles, Harold Bartlett with the oxen, and Donald Richardson on the right. (Courtesy G. Robert Merry.)

THE 1939 TERCENTENARY CELEBRATION.
Ruth Lambert Cheney is shown in period costume. She was a town benefactor and one of the founding members of the Rowley Historical Society. She is responsible for the English garden at the rear of the Historical Society's Platts-Bradstreet House, taken from a plan similar to one she saw in England. Ruth Cheney brought back English pottery from England to be used in the Rowley Powley Tea House to raise money for the restoration of the Rowley Historical Society's 1677 Platts-Bradstreet House. She also provided the early glass lights used in the window restoration of the house. (Courtesy Elizabeth Hicken.)

THE 1939 TERCENTENARY PAGEANT ON STAGE AT THE TOWN COMMON. Historical episodes depicting early town fathers were presented on a stage erected on the common. The towns of Georgetown and Boxford, representing a part of Rowley's early history, also participated in the pageant. (Courtesy Elizabeth Hicken.)

THE 1975 REENACTMENT OF ARNOLD'S EXPEDITION TO QUEBEC. Captain Dearborn's company is portrayed by Jon Dulude of Bedford, New Hampshire, with his dog. In the original expedition, the captain's dog had to be eaten to prevent starvation on the ill-fated 1775 trip to Quebec. (Courtesy Doris V. Fyrberg.)

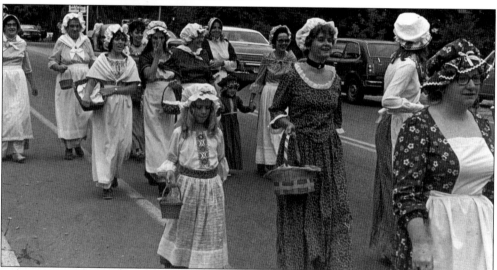

THE 1975 REENACTMENT OF ARNOLD'S EXPEDITION TO QUEBEC. The original Daughters of Liberty were the wives of the Rowley Militia that answered the alarm at Lexington. They then brought wagons of blankets and other provisions to Cambridge. These reenactors formed on Main Street at the Ipswich town line for the parade. Seen here are, from left to right, the following: (first row) Sharon Emery; (second row) Pamela Merry McKenzie, Ginny Merry, and Judith Robillard; (third row) Dolores Dealmeida, Carol White, Linda Taylor, Kate Fyrberg, and Ruth Gardner; (fourth row) Charlotte Kilgour, Harriet Saunders, Judy Boss, and Nancy Fowler. (Courtesy Doris V. Fyrberg.)

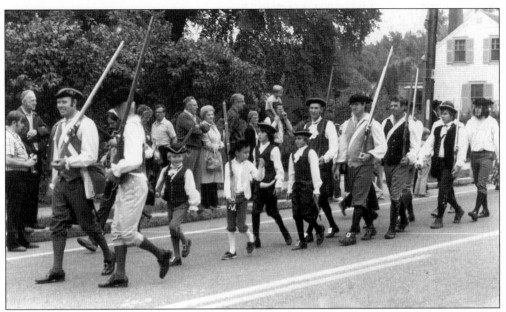

THE 1975 PARADE AT THE REENACTMENT OF ARNOLD'S EXPEDITION TO QUEBEC. The Rowley Militia is shown marching along Main Street. Those in the parade include John Mighill, Peter Fyrberg, Adam DiGenova, Thomas Hunter, Howard "Bud" Reith, Floyd Maker, Ronald Merry, Robert Merry, David Merry, Scott Boss, and Frederick Boss. (Courtesy Doris V. Fyrberg.)

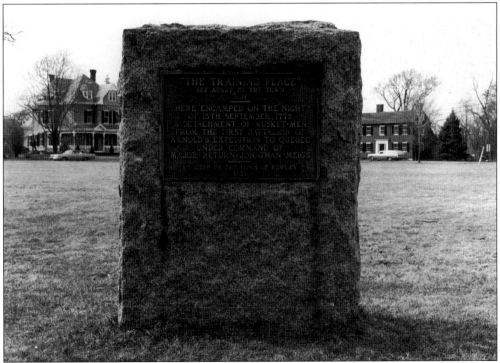

THE TABLET ON THE TOWN COMMON, 1975 PHOTOGRAPH. This area, known as the Training Place, was set apart by the town in 1639. In 1939, the town installed this tablet to commemorate the 1775 encampment of Arnold's expedition to Quebec. (Courtesy Doris V. Fyrberg.)

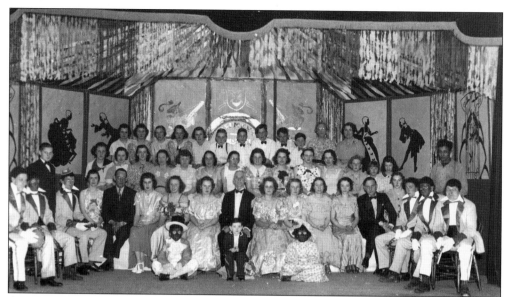

A MINSTREL SHOW PRESENTED ON THE SECOND-FLOOR STAGE OF THE ROWLEY TOWN HALL, C. 1940S PHOTOGRAPH. These shows were presented for winter entertainment during the 1930s and 1940s. The gentleman in the center, front row, was Mr. Interlocketer (master of ceremonies), performed by Cornelius F. Haley. (Courtesy Nathaniel N. Dummer.)

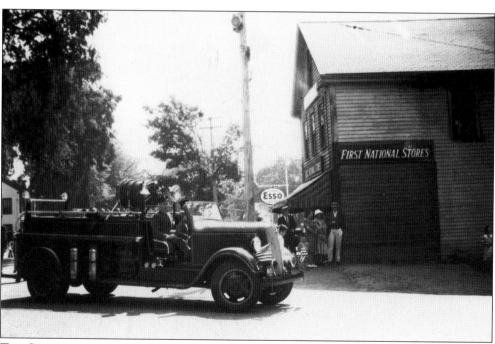

THE CELEBRATION AT THE END OF WORLD WAR II AT THE VILLAGE CENTER AT MAIN AND CHURCH STREETS, 1946 PHOTOGRAPH. Note the Evans Building (First National Store) on the right. The fire truck in the parade is Engine No. 2, a 1936 Dodge Maxim pumper. Robert Merry is shown as a youngster with his father, Gordon Merry, in the front seat of the fire truck. (Courtesy Elizabeth Hicken.)

Ten
PEOPLE, PLACES, AND THINGS

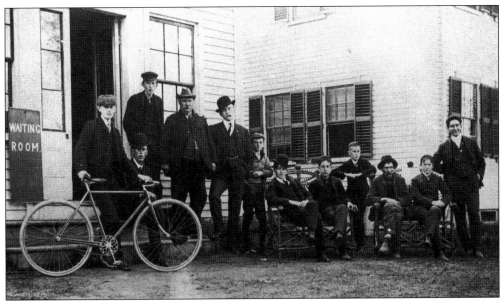

HIRAM KNEELAND'S STORE ON MAIN AND SUMMER STREETS, C. 1900 PHOTOGRAPH.
Passengers await the arrival of the electric car. Kneeland's Store was later moved to Central Street. The Smith-Billings House, on the right, held the original Rowley Powley Tea Room, which raised funds to restore the 1677 Platts-Bradstreet House, home of the Rowley Historical Society. (Curtis F. Haley Collection; courtesy Eva L. Haley.)

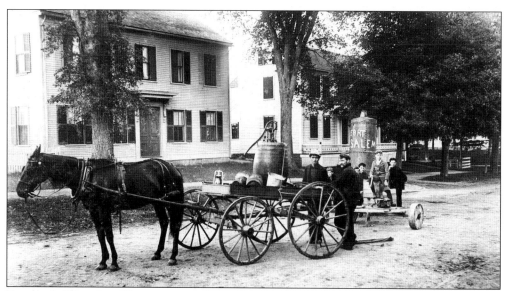

ROWLEY'S NEW ONE-HORSEPOWER FIRE ENGINE, JULY 4, 1900 PHOTOGRAPH. The building on the left is the present site of the post office and bakery, located on Main Street at Bailey's Corner. The two gentlemen in the foreground are William Prime (left) and Ernest Jellison. (Courtesy G. Robert Merry.)

ROWLEY'S FIREMEN IN FRONT OF THE HAMMOND STREET FIRE STATION, C. 1960S PHOTOGRAPH. The firefighters seen here are, from left to right, as follows: (front row) Alex Barowy, Chief Leonard Cook, Paul McCullough, Ralph "Pop" Hale, Frank McGlenn, Norman "Teet" Woodbury, and Stanley McCormick; (back row) Leo Deschenes, James Kenear, Raymond Saunders, John Lewis, Robert Perley, Ned Peabody, Armand Bouffard, and Fred Cheney. (Courtesy G. Robert Merry.)

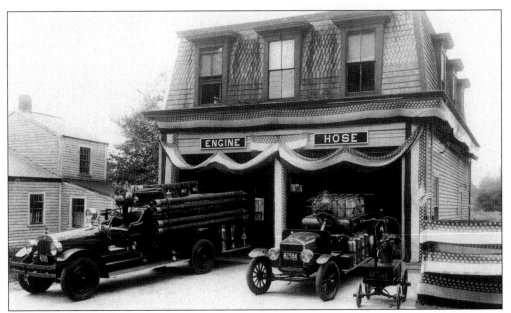

THE 1934 DEDICATION OF THE FIRE STATION ON HAMMOND STREET. The fire truck on the left is a 1928 Seagrave, the town's first fire engine. The fire truck in the center is a Model T Ford Hose No. 2, donated by Alec Good, a former fire chief. It was originally Good's peddler's wagon. The hand tub on the right, known as the Douglas, saved the Baptist church in the 1902 Boynton Block fire. This fire station on Hammond Street had been moved from Main Street in 1933 and was the former Jerry Todd's Grocery Store. (Courtesy G. Robert Merry.)

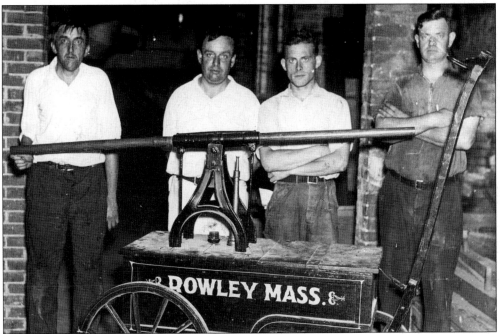

ROWLEY'S DOUGLAS HAND TUB, 1939 PHOTOGRAPH TAKEN IN THE TOWN HALL BASEMENT. Pictured here are, from left to right, Alfred Little, Alexander Good, Gordon Merry, and Harvey Saunders. (Courtesy Robert Merry.)

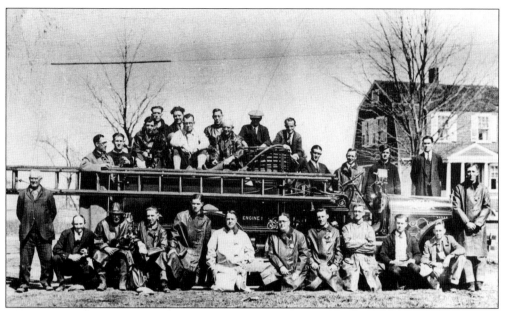

THE VOLUNTEER FIREMEN WITH THE NEW 1928 SEAGRAVE FIRE TRUCK. This picture was taken on Central Street in 1928. Shown here are, from left to right, the following: (front row) Fred Goodwin, Robie Manthorn, Thomas Peabody, Maynard Haley, Angus MacDonald, Frank Cook, Arnold Goodwin, Willard Worthley, Albert Haley, Edward MacDonald, Winfield Haley, and Newell Short; (middle row) Harold Blaisdell, Arthur Gordon, Edward Dow, John Curtis, and Ronald Perley; (back row) Arthur Cottrell, Chester Warden, Elmer Brown, Colin MacDonald, George Manthorn, Anthony Sheehan, James Hirtle, Harvey Saunders, and Fred MacDonald. (Curtis F. Haley Collection; courtesy Eva L. Haley.)

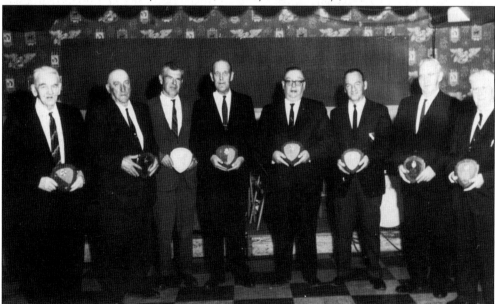

THE FORMER ROWLEY POLICE CHIEFS, C. 1960S PHOTOGRAPH. Pictured here are, from left to right, John Savage, Howard Ricker, Arthur Grover, Woodman H. Jewett, Alexander Good, Richard Field, Frances Madden, and Charles Foley. (Courtesy G. Robert Merry.)

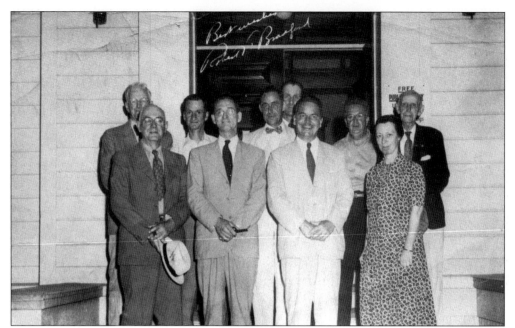

Town Officials in Front of the Town Hall on Main Street, c. 1950s Photograph. Shown here are, from left to right, the following: (front row) Harland Burke, Albert Haley, Massachusetts governor Robert Bradford, and Marian Todd; (back row) unidentified, John A. Perley, Eric Streiff, Arthur Gordon, Arnold Goodwin, and John A. Marshall. (Courtesy Town of Rowley.)

The Installation Ceremony at the Rowley Grange Hall on Central Street, 1953 Photograph. Pictured here are, from left to right, the following: (front row) Mildred Hardy, Ruth Pace, Margaret Ledford, an unidentified state officer, unidentified, Alice Schmidt, and Elizabeth Smith; (back row) Virginia Goodhue, Charlotte Bubier, Aldene Gordon, ? McGuire, Lou Jewett, Mary Babcock, Bertha Peabody, Ruth Sheldon, Oliver Worthley, Willard Worthley, and unidentified. (Courtesy G. Robert Merry.)

117

HOWARD C. ROGERS AND HIS DOG DUKE, 1898 PHOTOGRAPH. This photograph was taken outside of a cottage on Stackyard Road. Note the dog sitting in the wagon with the Goodwill Soap advertisement. (A.O. Rogers Collection; courtesy Scott Nason.)

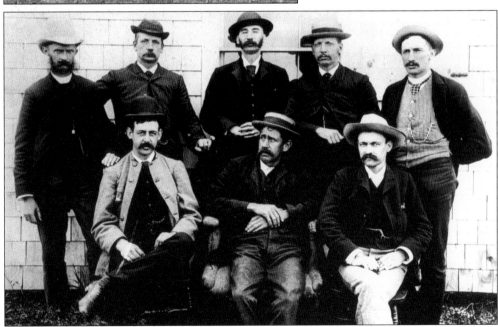

A GROUP AT NELSON'S ISLAND, C. 1900 PHOTOGRAPH. Local businessmen enjoy an outing at Nelson's Island. Pictured here are, from left to right, the following: (front row) Frank L. Burke, Edward "Duke" Richardson, and Everett Hale; (back row) Bernard Damon, Augustus Boynton, Frank Henderson, Arthur Bishop, and Albert "Ed" Bailey. (Courtesy G. Robert Merry.)

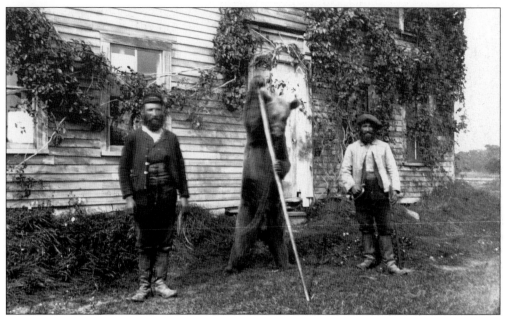

A Bear Performing in Rowley, 1899 Photograph. This bear was possibly part of a traveling circus troupe. (A.O. Rogers Collection; courtesy Scott Nason.)

B.F. Foster as a Child, 1897 Photograph. In this interior view, note the turn-of-the-century Victorian furnishings in the background. (A.O. Rogers Collection; courtesy Scott Nason.)

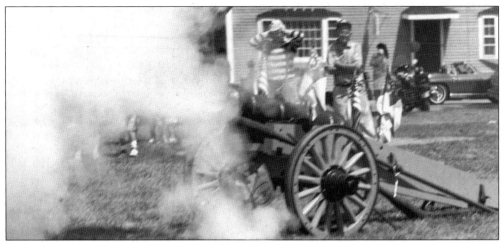

THE FIRING OF ROWLEY'S OLD NANCY AT A FOURTH OF JULY CELEBRATION ON THE TOWN COMMON, 1988 PHOTOGRAPH. The cannon is fired off by current cannoneer, G. Robert Merry, to celebrate special town events. (Photography by KMA; courtesy G. Robert Merry.)

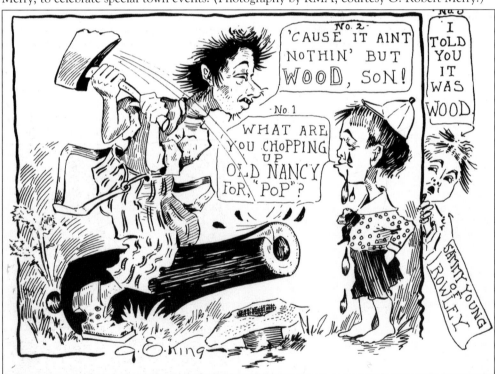

A CARTOON OF OLD NANCY BY GEORGE E. KING, C. 1900. This illustration shows Willie Green's father, of Georgetown, "chopping some extra firewood." On July 27, 1877, a demonstration and parade were organized so that both Georgetown and Rowley could fire their cannons, as Georgetown had claimed to have the original. The Georgetowners mounted their gun in an express wagon protected with a contingent of armed and mounted guards. During an unguarded moment, Joshua Hale of Rowley, perceiving that the wagon springs did not settle as they should, thrust his pocketknife into the Georgetown cannon. It was made of wood. Need we say more as to who has the real Old Nancy? (Courtesy G. Robert Merry.)

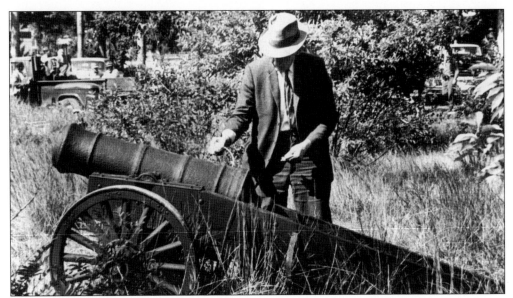

THE FIRING OF ROWLEY'S OLD NANCY AT A FOURTH OF JULY CELEBRATION, C. 1950S PHOTOGRAPH. The cannon is ready to be fired by Lawrence "Lobby" Bishop, who was Rowley's cannoneer for approximately 40 years. With the capture of the British ordinance ship *Nancy* in Gloucester during the American Revolution, its cargo was unloaded and one of her cannons left on the dock, remaining there for years. The cannon was eventually purchased by Rowley merchant Maj. Eben Boynton, who had one son living in the West Parish and the other in the East Parish—each claimed the cannon after their father died. When Georgetown separated from Rowley in 1838, the cannon became an inter-town wrangle, and the towns stole the cannon from each other over the years. (Curtis F. Haley Collection; courtesy Eva L. Haley.)

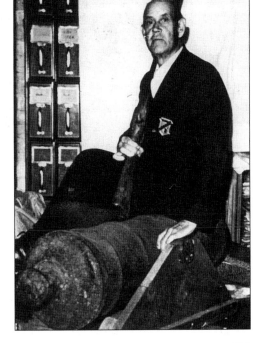

"HAZE" JEWETT GUARDING OLD NANCY IN THE ROWLEY TOWN HALL VAULT, C. 1930S PHOTOGRAPH. Former police chief Jewett is shown with his double-barreled shotgun, protecting one of the treasures of the town. In 1876, Old Nancy was brought back to Rowley to remain here permanently and was locked safely in the town hall vault for many years. (Courtesy G. Robert Merry.)

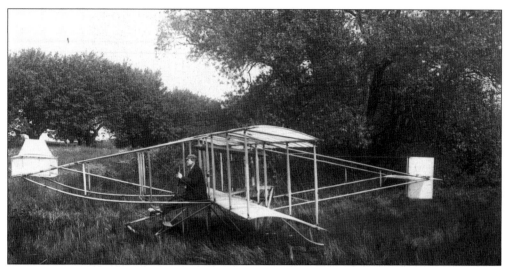

EARLY AVIATION: THE HERRING-BURGESS AEROPLANE AT NELSON'S ISLAND, 1910 PHOTOGRAPH. J. Starling Burgess was the inventor of the Herring-Burgess plane, and his company produced approximately 100 aeroplanes. A frequent visitor to the Rowley marshes, Burgess soon realized that while skids on the plane worked well on the wet marsh grass, wheels were a more effective landing gear. He was later licensed by the Wright brothers to build the Wright Model B plane. Note the apple orchard in the background on Nelson's Island. (Marian G. Todd Collection; courtesy Frank and Shirley Todd.)

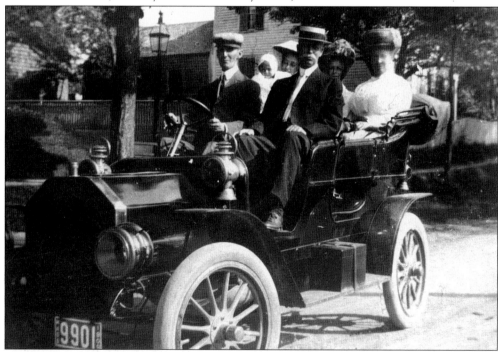

HARLAND FOSTER (DRIVER) AND FAMILY IN ROWLEY'S SECOND AUTOMOBILE IN 1906. The Foster family goes out for an afternoon spin. There were no wind-screens in these early cars and goggles were needed. Note the right-hand drive in this early touring car. (Courtesy G. Robert Merry.)

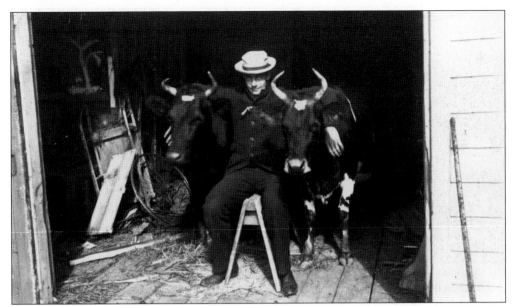

FRANK FOSTER WITH HIS TWO PRIZED OXEN AT HIS HAMMOND STREET BARN, 1898 PHOTOGRAPH. This farm is now known as the Savage Farm. (A.O. Rogers Collection; courtesy Scott Nason.)

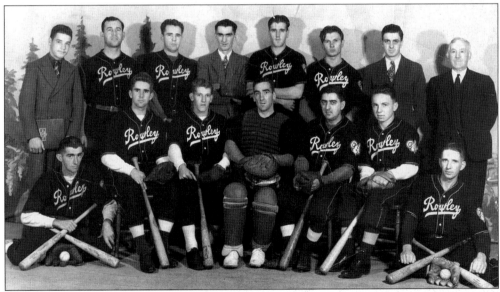

THE ROWLEY RAMS BASEBALL TEAM, 1938 PHOTOGRAPH. This was the region's championship team in 1938. Joe Reagan was hired to catch and was paid $2 per game. In the back right is Joe Reagan's father, who was voted "fan of the year" because he attended all of their games. Pictured here are, from left to right, the following: (front row) Benny Millett, Curt Haley, Charles Short, Joe Reagan, Kenneth Morong, and William Smith; (back row) Fred Emerson, Edward MacDonald, Melvin Haley, manager Sumner Bruce, Edmund Sheehan, "Zowie" Gibbs, Jerry Jedrey, and Mr. Reagan. (Courtesy G. Robert Merry.)

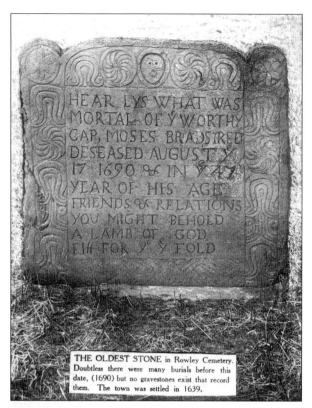

THE OLDEST STONE in Rowley Cemetery. Doubtless there were many burials before this date, (1690) but no gravestones exist that record them. The town was settled in 1639.

THE OLDEST STONE IN THE ROWLEY CEMETERY ON MAIN STREET. Capt. Moses Bradstreet was buried in 1690; his is the oldest recorded burial in town. There were many burials of early settlers before this date, but no gravestones exist that record them. The town was settled in 1639. (Charles Houghton Collection; courtesy Doris V. Fyrberg.)

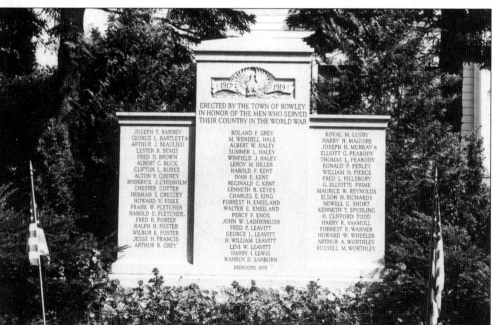

THE WORLD WAR I MONUMENT IN FRONT OF THE TOWN HALL ON MAIN STREET, C. 1935 POSTCARD. The monument was dedicated in 1935. The two stars signify George L. Bartlett and Joseph H. Murray, men who were killed in action during the war. (Courtesy Elizabeth Hicken.)

THE WELL-KNOWN ROWLEY CRUSADERS GROUP, 1930 POSTCARD. This evangelical group of young men toured throughout the country singing and preaching the gospel. Pictured here are, from left to right, the following: (first row) Hollis Hamilton, Paul A. Dodge, Carl Savage, and Donald Hamm; (second row) Palmer Perley, F. Payson Todd, and Francis Morong; (third row) Lawrence Chase and Arnold Hamilton; (fourth row) Asa Melenjer. (Courtesy G. Robert Merry.)

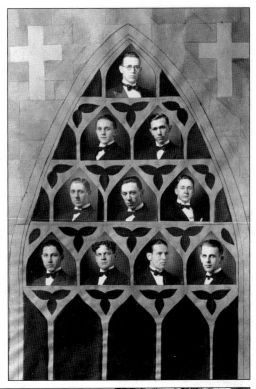

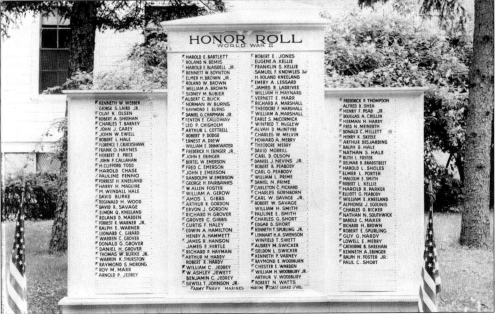

THE WORLD WAR II MONUMENT IN FRONT OF THE TOWN HALL ON MAIN STREET, 1943 POSTCARD. A committee that consisted of Willard K. Worthley, Milford Daniels, and Edward F. MacDonald was formed in 1943 to construct a wooden monument on this site. The wooden monument, erected in 1943, was replaced in 1950 with a granite monument. (Courtesy G. Robert Merry)

CHARLES "BONESY" LEAVITT ON THE TOWN'S MOTH DEPARTMENT SPRAYER, C. 1940S PHOTOGRAPH. Bonesy was a long-time employee of the town and resident of Hammond Street. His grandson, Scott Leavitt, is presently the town's highway surveyor and tree warden. (Courtesy Scott Leavitt.)

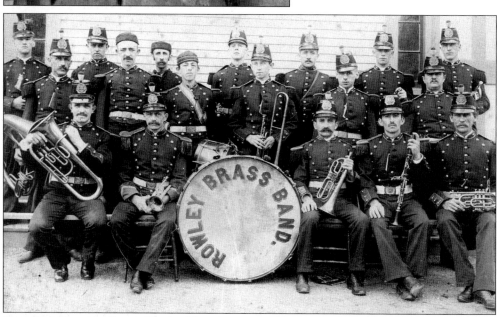

THE OLD ROWLEY BRASS BAND, MAY 30, 1889 PHOTOGRAPH. The original Rowley Brass Band was organized in 1881. This photograph was taken on the steps of the Baptist church. Pictured here are, from left to right, the following: (front row) Harry A. Jaques, Charles H. Todd, Charles E. Marshall, Albert Crampsey, and Edward Alvin Daniels; (middle row) James P. Rundlett, George P. Batchelder, William E. Sherburne, Stephen O. Kent, John C. Burke, and Edward Dillon; (back row) George L. Wilson, Fred K. Goodwin, Augustus A. Peabody, Austin Kelley, James A. Rogers, Alvah G. Stockbridge, and Amos Everett Jewett. (Photograph by Willard M. Carpenter; courtesy Doris V. Fyrberg.)

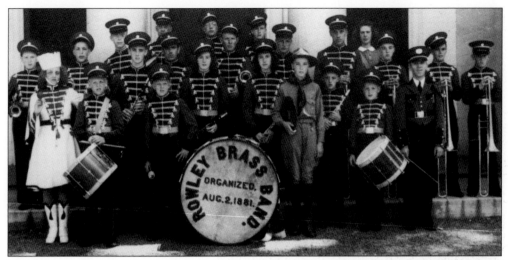

THE ROWLEY SCHOOL CADET BAND ON THE STEPS OF THE CONGREGATIONAL CHURCH, C. 1940S PHOTOGRAPH. Note that the group is using the original Rowley Brass Band drum. Shown here are, from left to right, the following: (first row) Christie Woodbury, Robert Burke, Richard Burke, Robert Cressey, Walter Babcock, and band leader Edward G. Preble; (second row) Kenneth Todd Jr., Celia Mallard, Ruth Johnson, and Donald Sheehan; (third row) Douglas Savage, Wendell Warner, Joseph Dupray, Delbert Kent, Alfred Babcock, Vincent Peabody, Edward Sheehan, Donald Blaisdell, and Donald Varney; (fourth row) Albert W. Haley, Harold Blaisdell, Charles Woodbury, Al Hulbert, and Eleanor Johnson. (Courtesy G. Robert Merry.)

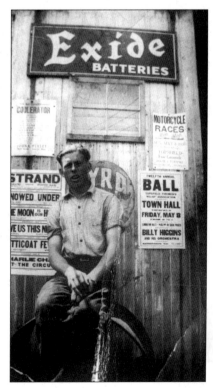

GORDON MERRY OUTSIDE THE MACDONALD BROTHERS GARAGE ON CENTRAL STREET, C. 1930S PHOTOGRAPH. Note the graphic posters in the background. (Courtesy G. Robert Merry.)

A.O. ROGERS, ROWLEY PHOTOGRAPHER, IN 1897. A.O. Rogers's business was located at 4 and 6 Hammond Street. Rogers documented life in Rowley at the turn of the century. Many of the early photographs that appear in this book are the works of the two gentlemen on this page. (A.O. Rogers Collection; courtesy Scott Nason.)

ROWLEY PHOTOGRAPHER CHARLES HOUGHTON, A MAN OF MANY OCCUPATIONS, C. 1920S. Besides being a photographer, Houghton was a printer, an owner of a bakery store, and a well-known taxidermist who traveled extensively to collect bird specimens. The collection was left to the town and can be seen on the second floor of the town hall. He was also the first president of the Rowley Historical Society. (Courtesy Town of Rowley.)